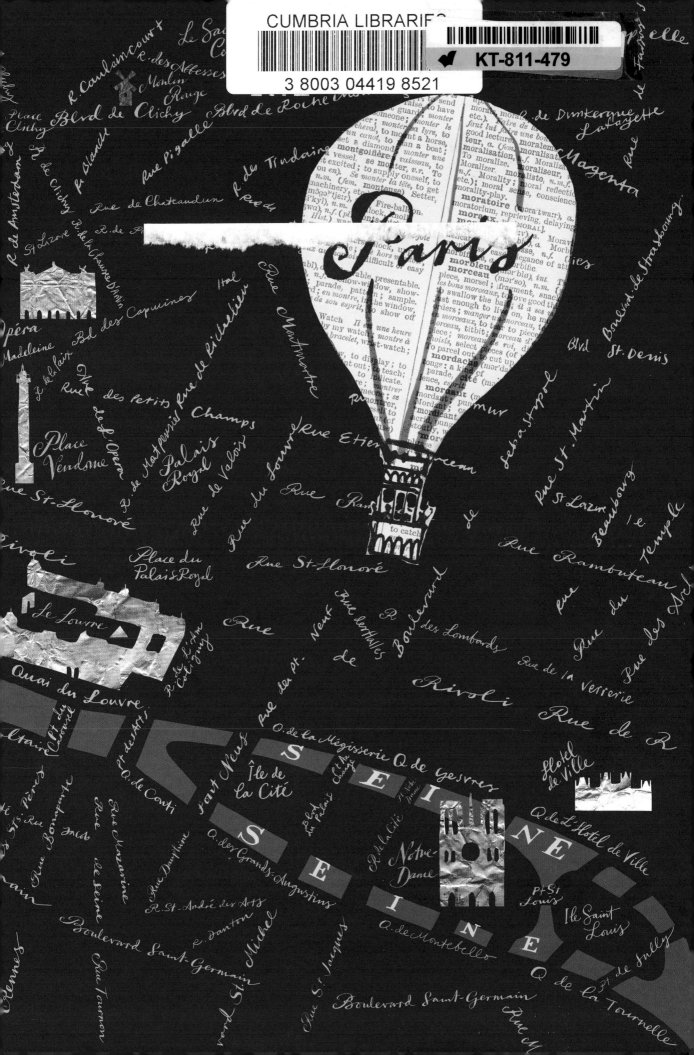

Paris Sketchbook

Jason Brooks

Laurence King Publishing

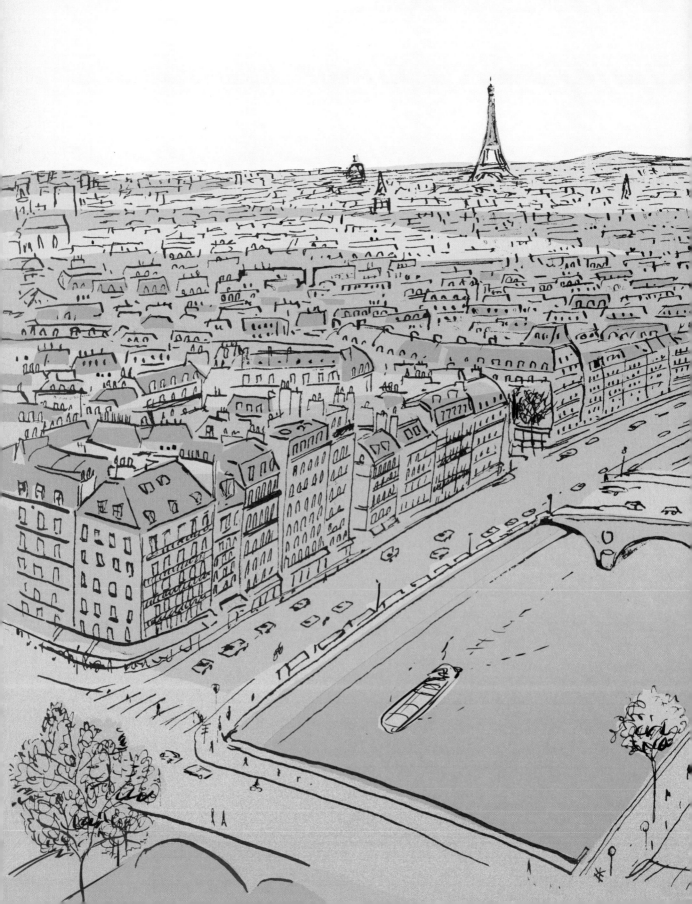

Paris

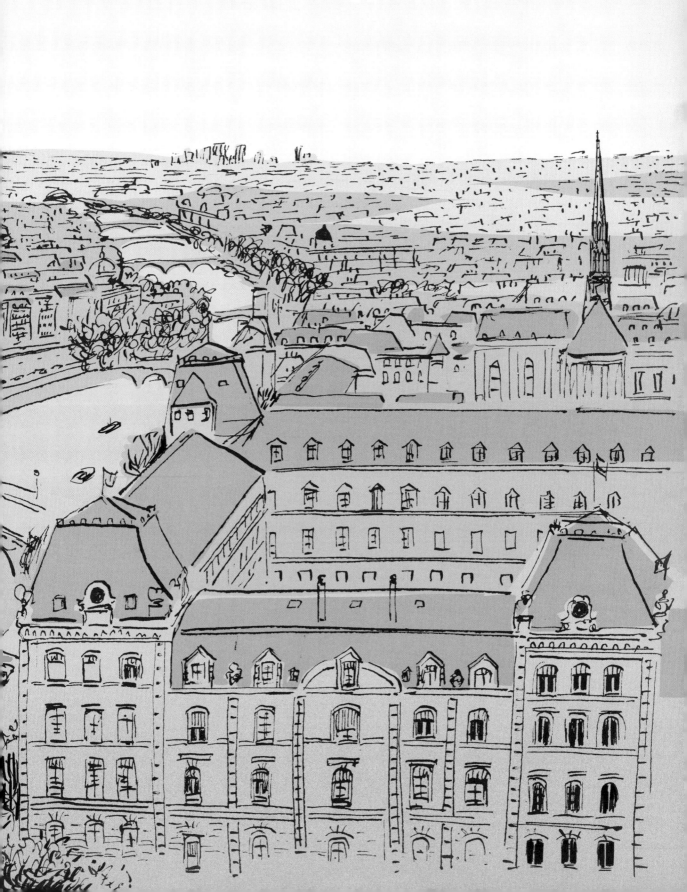

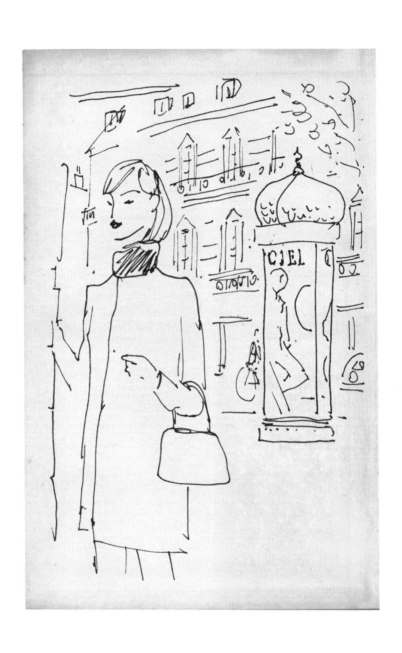

Contents:

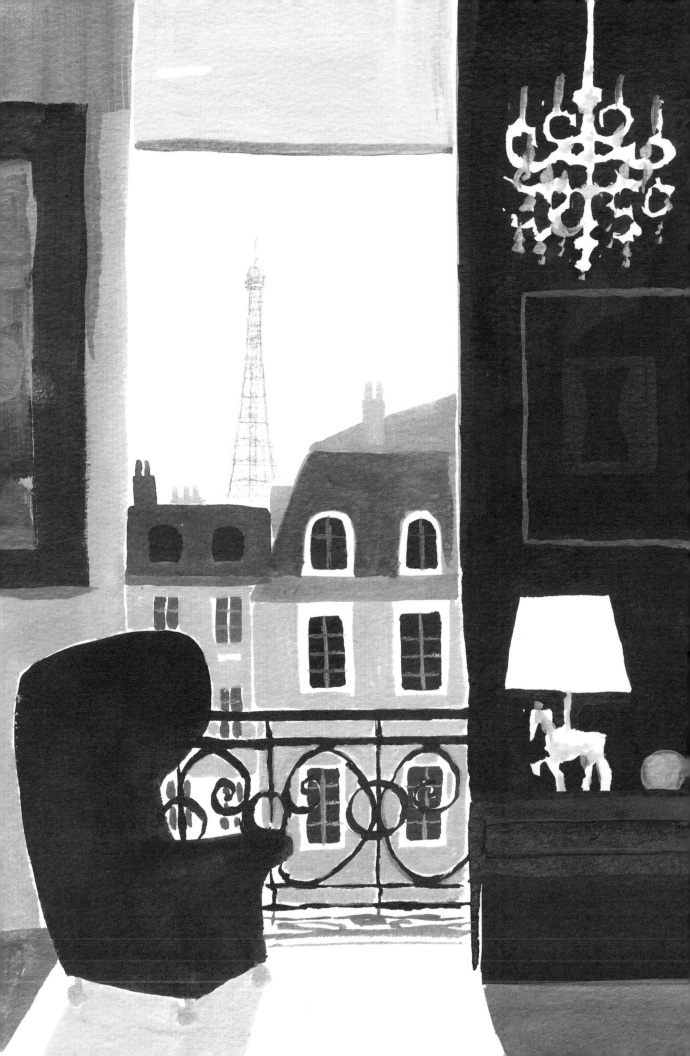

Introduction

Arriving in Paris at the Gare du Nord on a crisp autumn day. The milling crowds wear their clothes in an artfully precise way, at once casual, yet considered, as we wait in line for shiny black taxis. In no time the streets of Paris are whistling past my window.

The elegantly weathered typography of a shop sign slides by above a young couple sharing a scooter, their laughing faces half-obscured by sunglasses. We round a corner café as a waiter in white shirt and black waistcoat lowers a coffee onto the table of a man who resembles a French Alfred Hitchcock. Beside him a small dog lies patiently, as the man reaches inside his jacket for a cigar. A woman near a street crossing is reduced for a moment to a blurred silhouette-like fashion plate, her pale face framing a smudge of red lipstick. Our car is momentarily reflected in a patisserie window, superimposed onto an arrangement of architectural cakes in saturated oranges, pinks and yellows against the sophisticated palette of dark greys, blues and pebble colours of the city.

Above the street, lines of balconies stretch upwards to zinc roofs studded with windows and fringed with chimney pots. The sky above is a clear china blue and draped with soft clouds. Crossing the Seine, it appears like a wide glittering swathe of fabric striped with bridges and flanked by picturesque buildings, while to the west the familiar shape of the Eiffel Tower is visible. I reach inside my bag for a sketchbook and pen. My adventure in Paris has begun...

This book is a collection of drawings, collages, notes and sketches from several trips to Paris. I have arranged it into themed chapters in order to share more clearly my responses to this beautiful city.

I hope it will take you on a pleasing journey of your own...

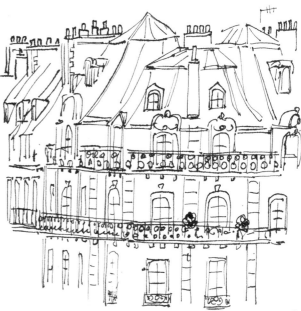

PARIS
PARIS
PARIS

Paris
PARIS
PARIS
Paris
PARIS.
PARIS
PARIS
Paris
PARIS
PARIS
PARIS

PARIS

PARIS
PARIS
Paris
PARIS
°PARIS°
Paris
PARIS
PARIS
PARIS
PARIS
Paris
PARIS
PARIS

Architecture

Paris, City of Light, with its elegant buildings, wide boulevards and myriad rooftops, stands apart from other capital cities for its unique and much-celebrated beauty. The very word 'Paris' serves as shorthand for all that is romantic, nostalgic and glamorous.

The architecture of Paris has a particular elegance and coherence in the repetitions and rhythms of its details which seem to suggest romantic narrative. Shutters that could be drawn to close out the wider world, balconies for sharing breakfast or reading a novel, rooftop windows that provide glimpses into private worlds or access from within to the pearly skies of Paris above. Cafés and Metro entrances appear to be designed as the location for a fleeting rendezvous or contemplative reverie.

The public buildings of Paris also make the heart soar, from the curved greenhouse roof of the Grand Palais, visible above the treetops, to the exotic wedding cake of the Sacré-Coeur, and on to the most visible structure of all: the Eiffel Tower, the very symbol of Paris.

Paris was originally founded as the Roman city of Lutetia some 2,000 years ago. After the fall of the Roman Empire, it became a medieval city of dark alleyways and narrow streets. Through subsequent waves of planning and rebuilding, particularly by Baron Haussmann in the 19th century, order and symmetry were gradually introduced.

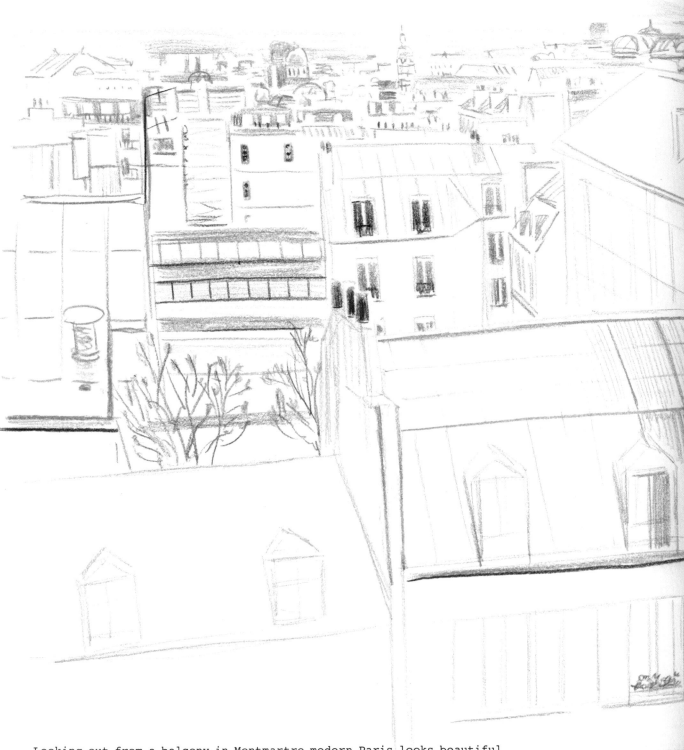

Looking out from a balcony in Montmartre modern Paris looks beautiful and ordered but still retains just a hint of that medieval chaos.

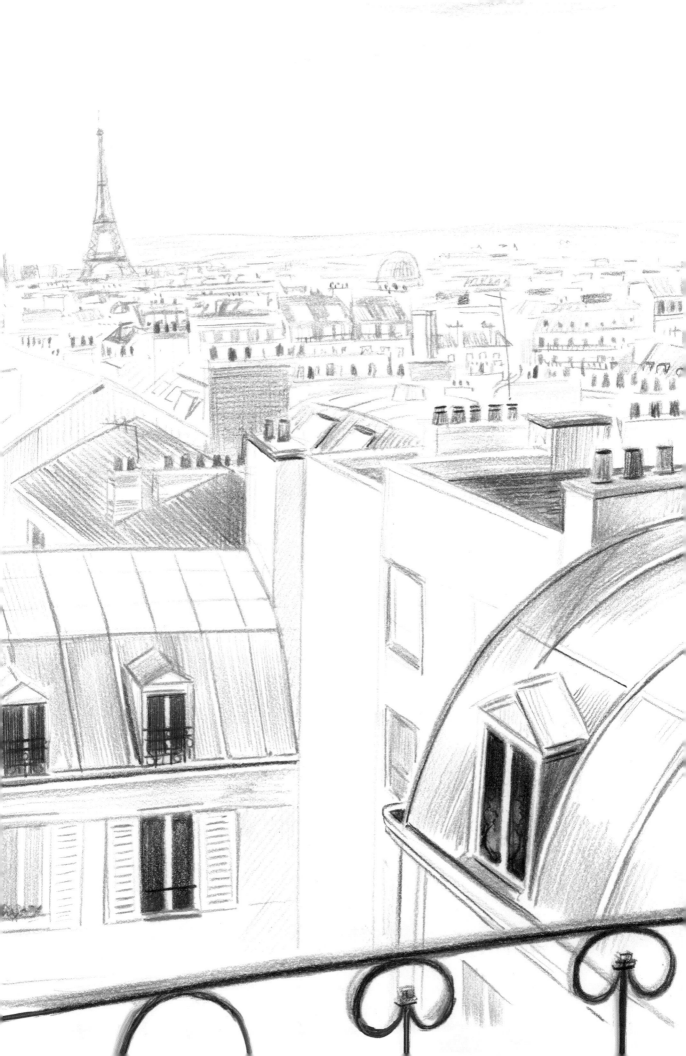

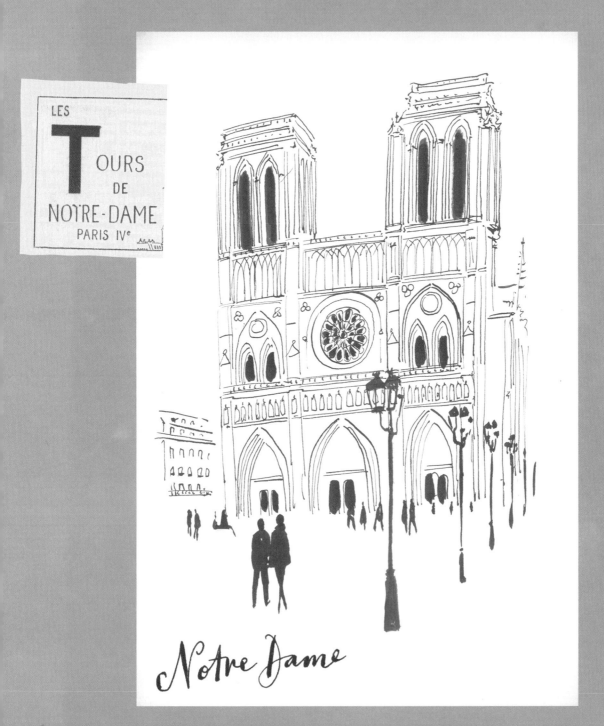

LES **T**OURS DE NOTRE-DAME PARIS IVᵉ

Notre Dame

Above: The imposing cathedral of Notre-Dame lies at the geographic centre of the city, with its twin Gothic towers and ornate west façade. On a dark night in October it's easy to imagine Victor Hugo's Quasimodo surveying the scene below.

Opposite: The July Column in the Place de la Bastille commemorates the events of the July 1830 revolution. The figure on top of the column is the 'Génie de la Liberté' or 'Spirit of Freedom'.

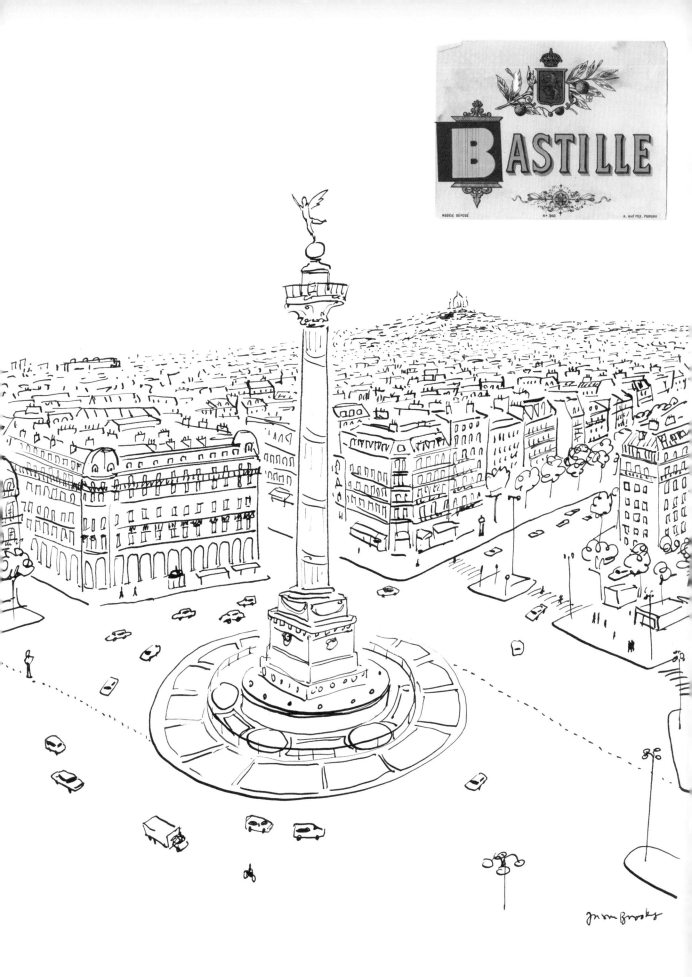

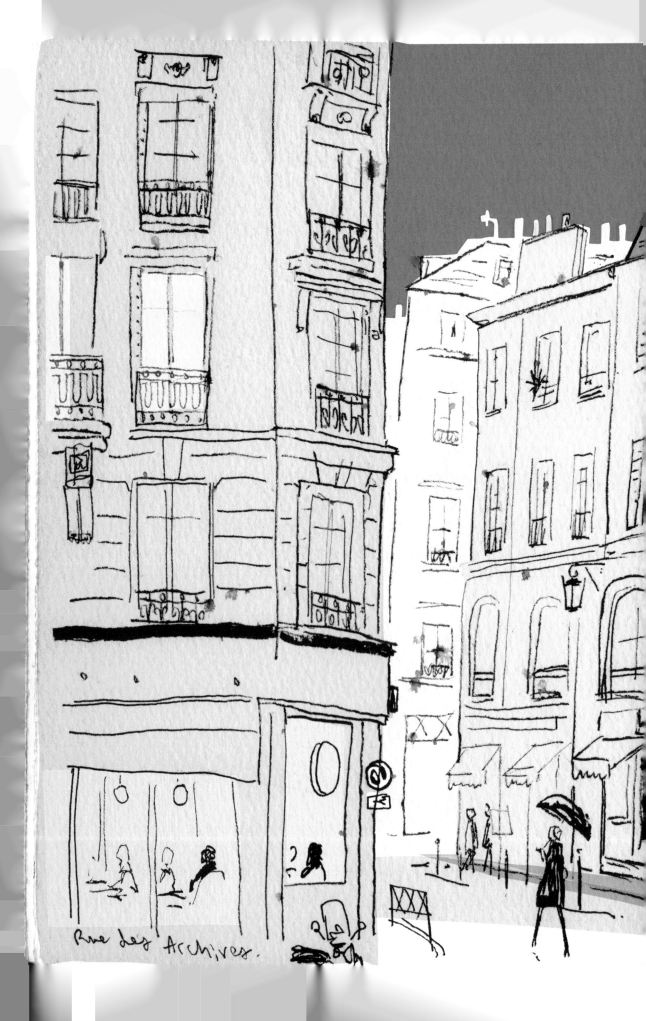

Rue des Archives.

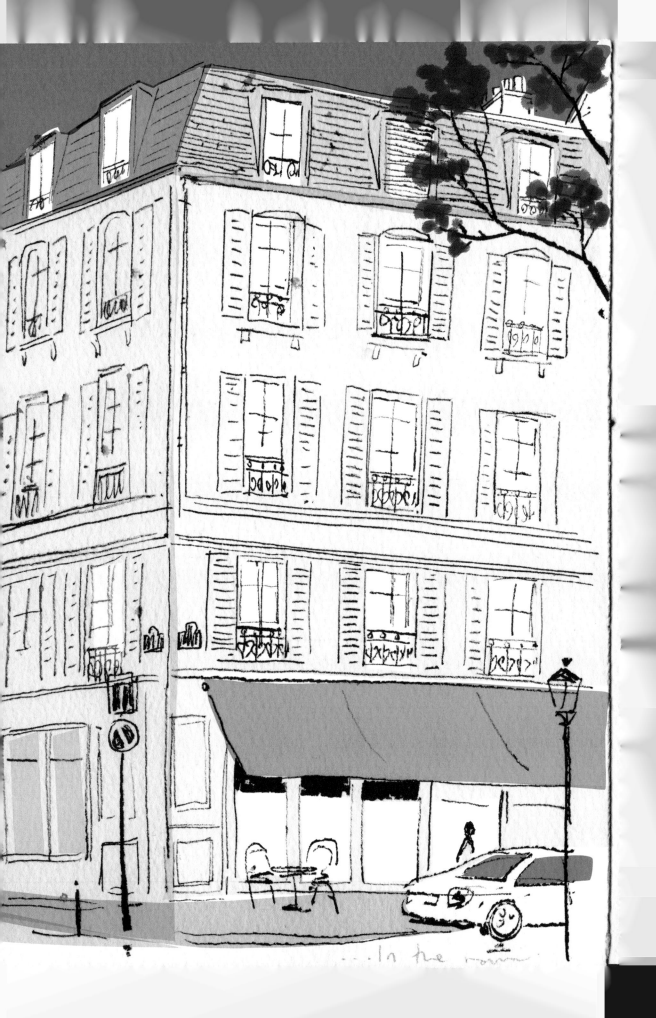

PARIS

Souvenir de la Tour Eiffel

La Tour Eiffel

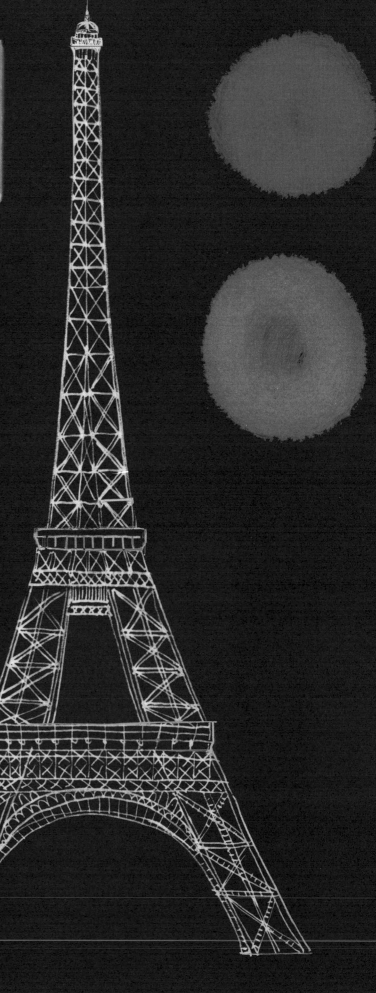

'We'll always have Paris'

Casablanca

'We'll always have Paris.'

Casablanca

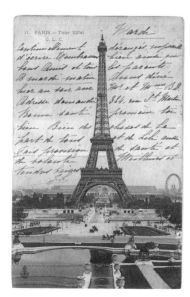

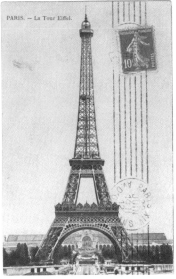

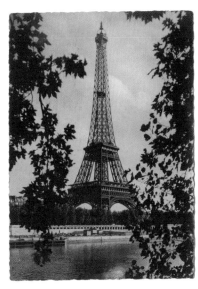

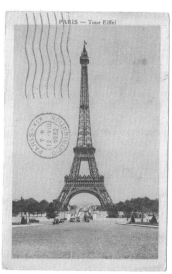

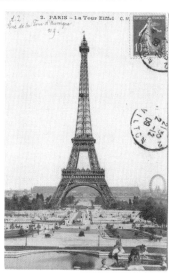

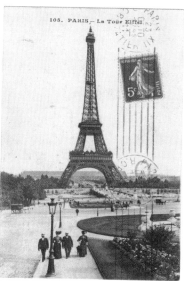

The Eiffel Tower has gone from avant-garde statement to beloved and ubiquitous symbol of Paris. I now have quite a collection of old postcards of the tower, some of which are shown on this page. My favourite is the last one on the right: I love how the clothing of the people in the foreground suggests time has changed everything but the tower itself.

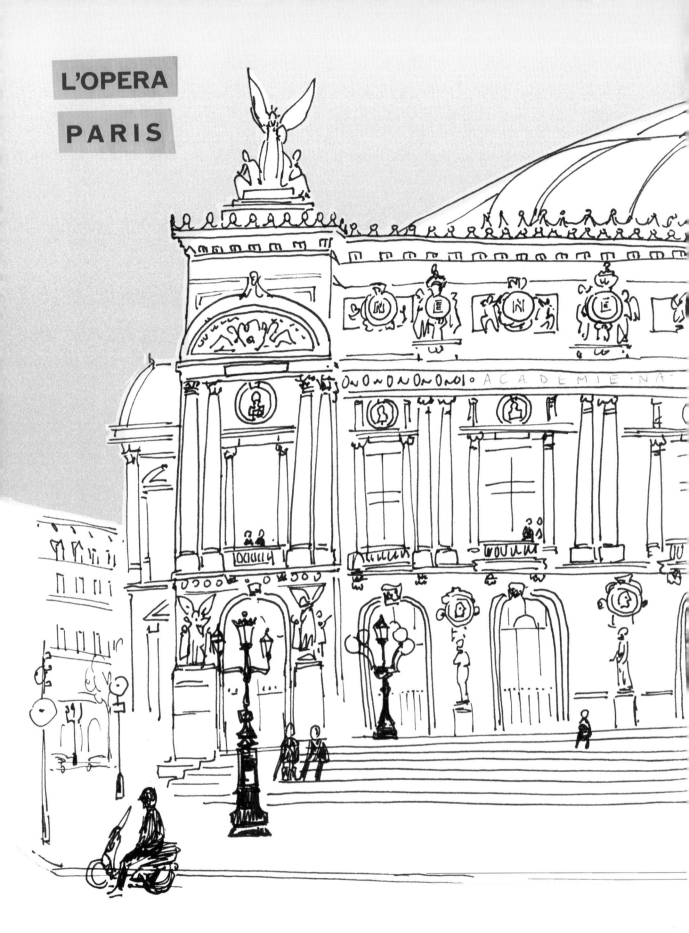

The Palais Garnier opera house stands symmetrically like a giant jewelled music box facing down the long Avenue de l'Opéra. The opera house was opened in 1875 and was the setting for Leroux's novel *The Phantom of the Opera*. Just as in the story, it reportedly has an underground 'lake' deep in its cellars.

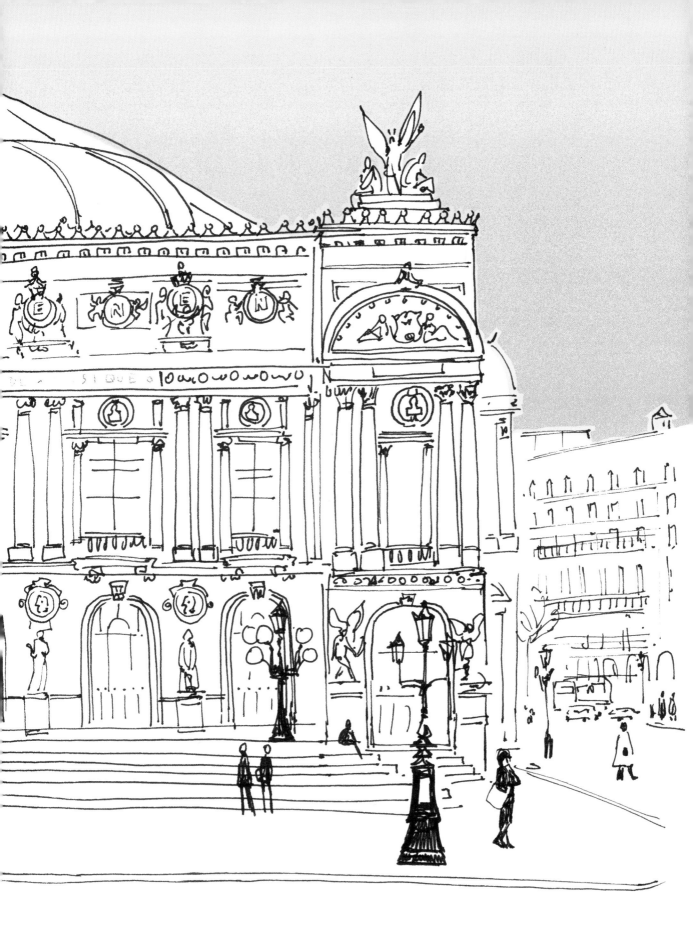

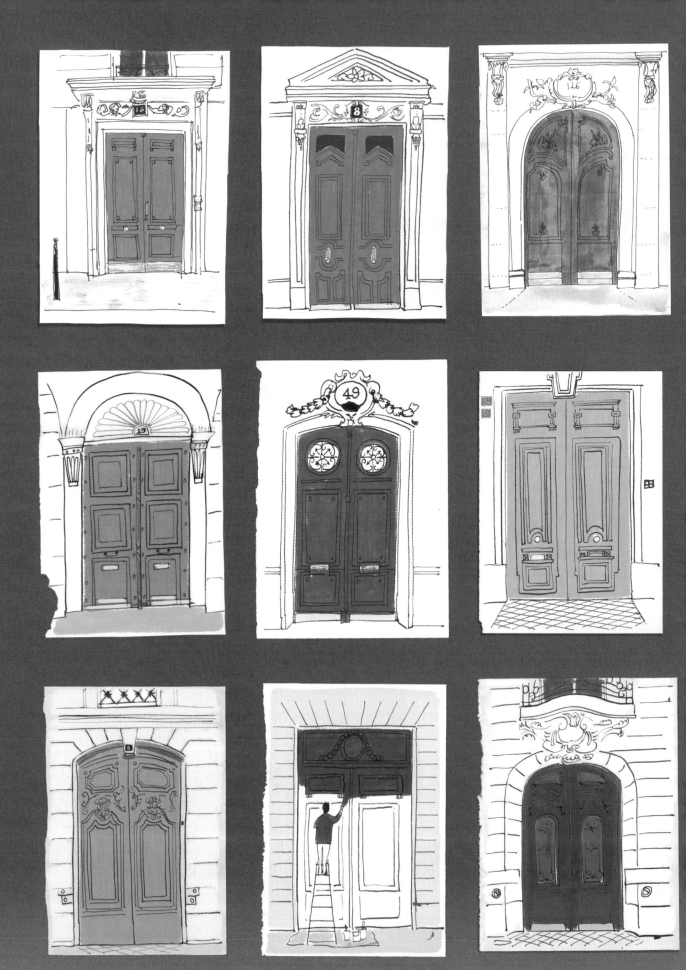

The variety of doorways and their architectural details are
fascinating and residents seem to take great pride in them.

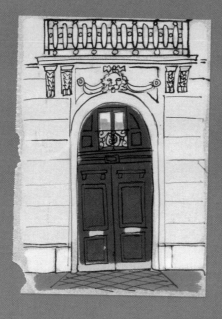
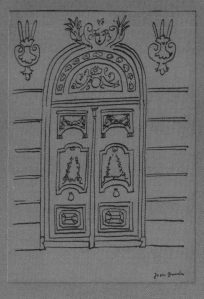
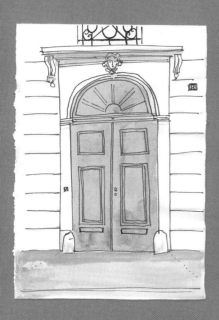
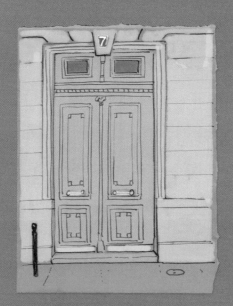
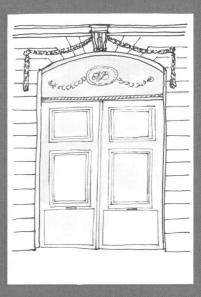
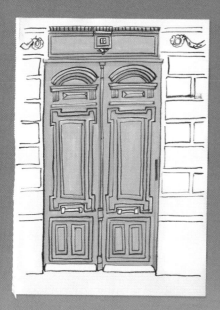
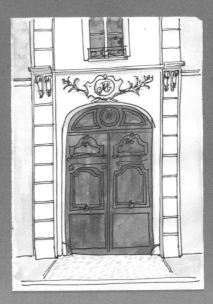
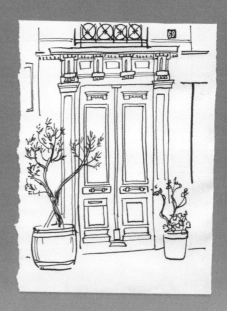

Letterboxes and handles are polished to a mirror-like sheen
and colours chosen from a sophisticated Parisian palette.

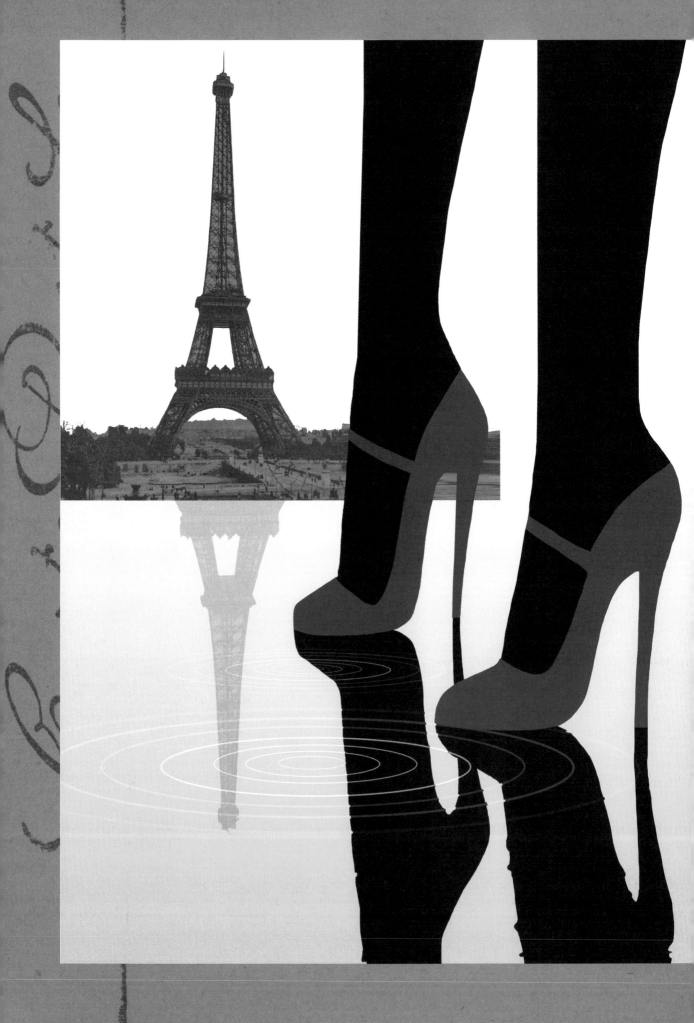

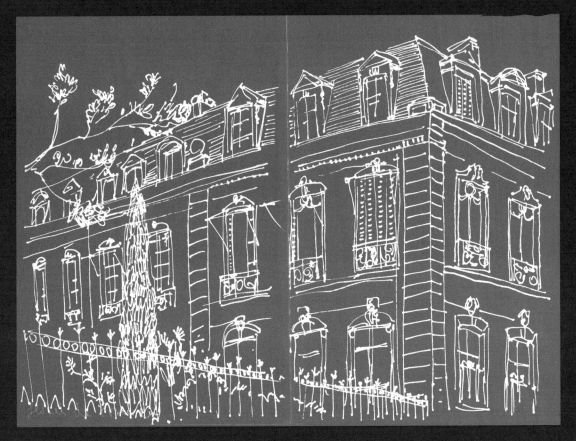

Above: This old hôtel near the Musée d'Orsay is one of my favourite buildings in Paris - I love the tall windows that face out onto its own secluded garden. In Paris, 'hôtel' means a type of large town house.

Below: Tin foil cut-outs of some of the iconic landmarks of Paris.

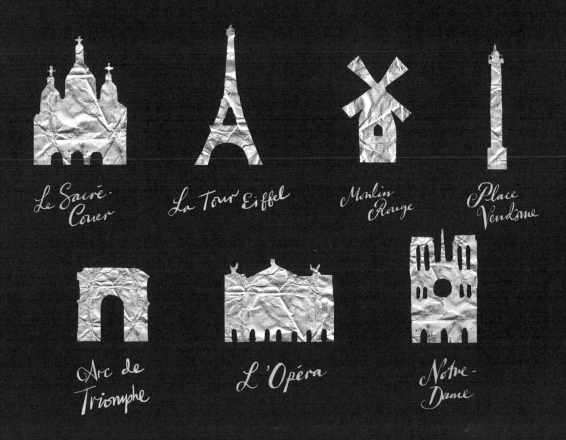

Le Sacré-Cœur La Tour Eiffel Moulin Rouge Place Vendôme

Arc de Triomphe L'Opéra Notre-Dame

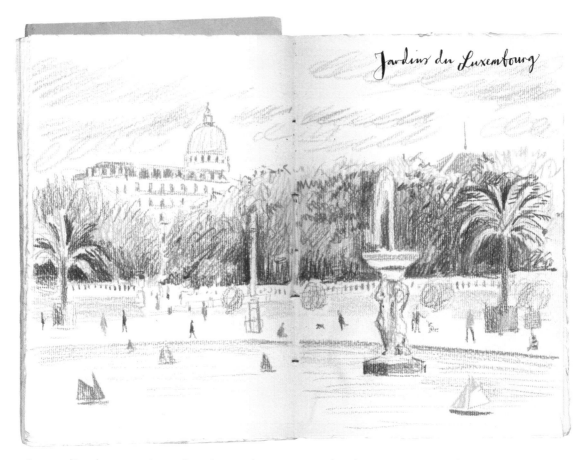

The Jardins du Luxembourg boating pond on a warm day in June. The whole scene feels like being in a painting by Seurat.

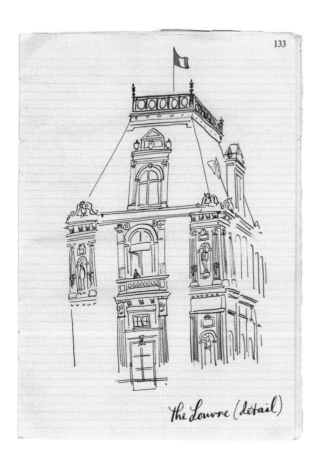

the Louvre (detail)

A woman in a red dress on a balcony at the Louvre, emphasising the building's massive scale.

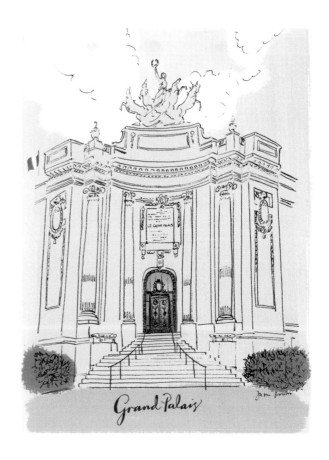

Grand Palais

One of the entrances to the Grand Palais.

Basilica

Sacré-Coeur

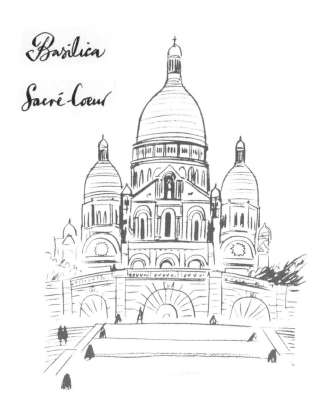

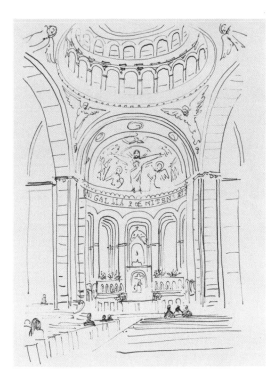

The Sacré-coeur Basilica looks like it could be made from white icing sugar but it's actually travertine from nearby Seine-et-Marne which is said to exude calcite as it erodes. making it retain its whiteness.

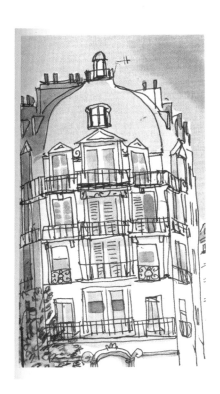

Haussmann Rooftops

Place des Victoires

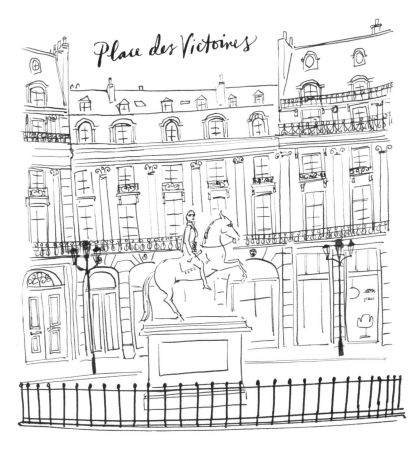

Many Parisians live right under the roofs of the buildings in vaulted lofts and angled attics.

The Place des Victoires is like a huge ornate circular frame for the equestrian statue of Louis XIV at its centre.

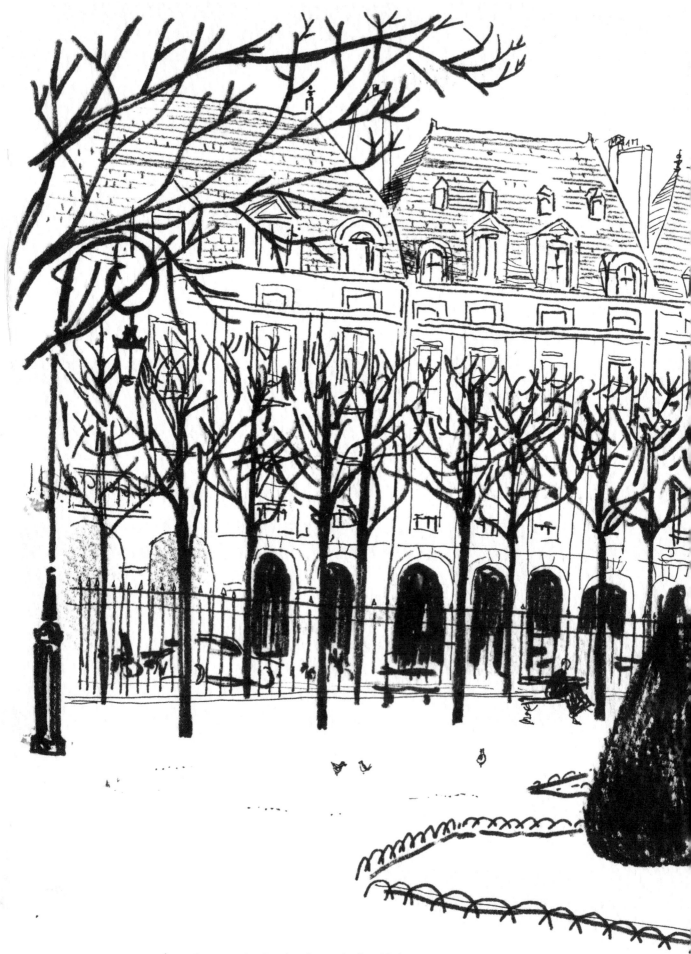

The Place des Vosges, built at the beginning of the 17th century.
This is mid-winter, when the precisely clipped trees form a
continuous screen of stark interlaced branches in front of the
arcaded buildings.

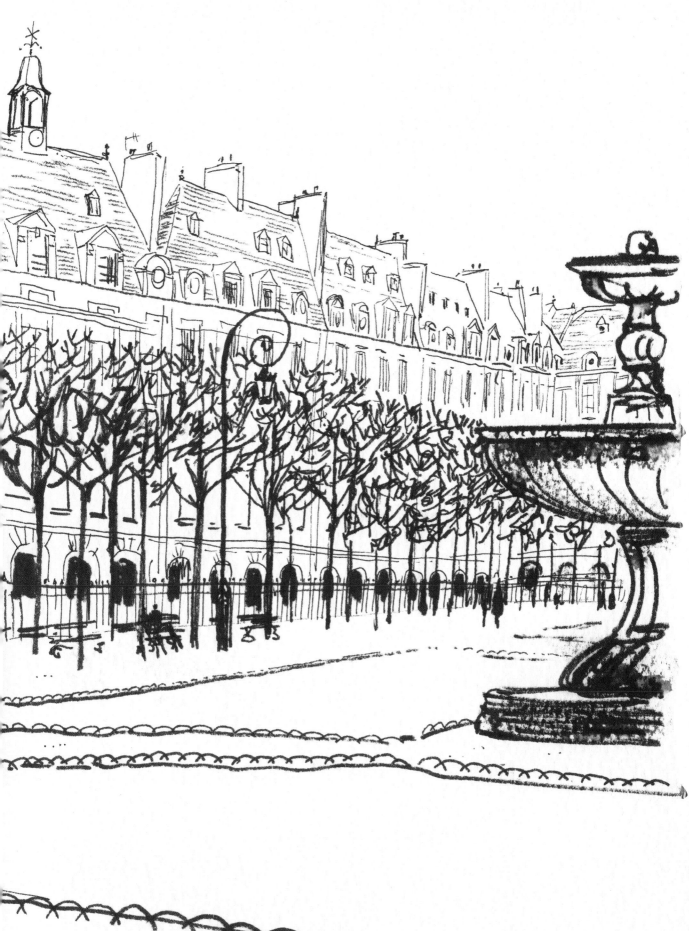

Place des Vosges

High up in Montmartre, just outside the Salvador Dalí museum.
On the right between the buildings the Eiffel Tower is just
visible. The rectangular building in the distance on the left
is the Tour Montparnasse.

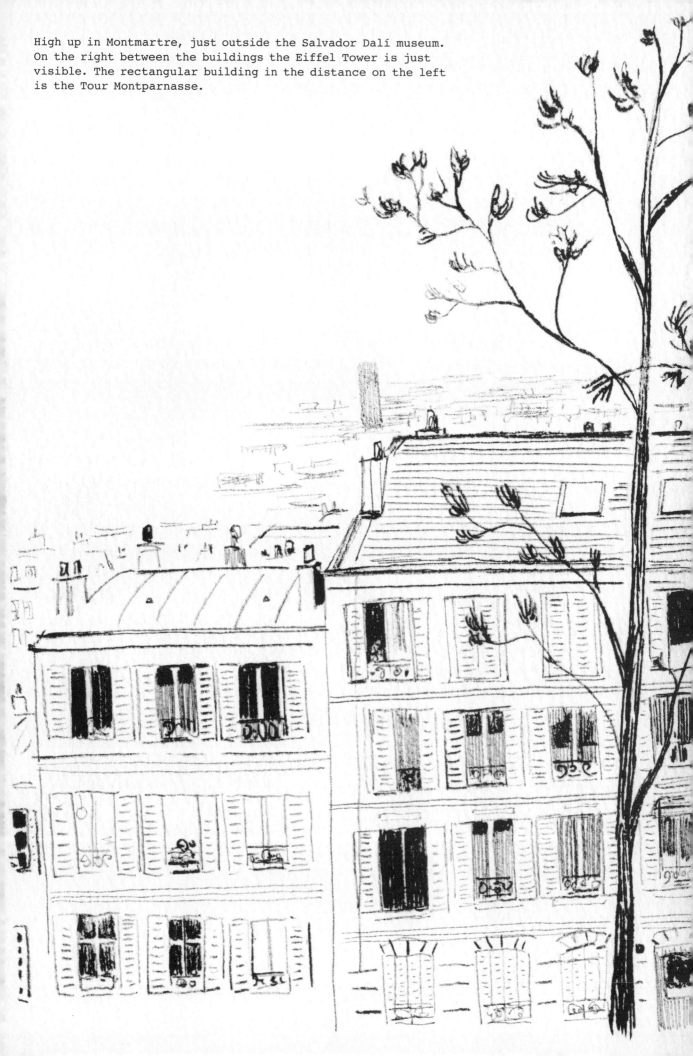

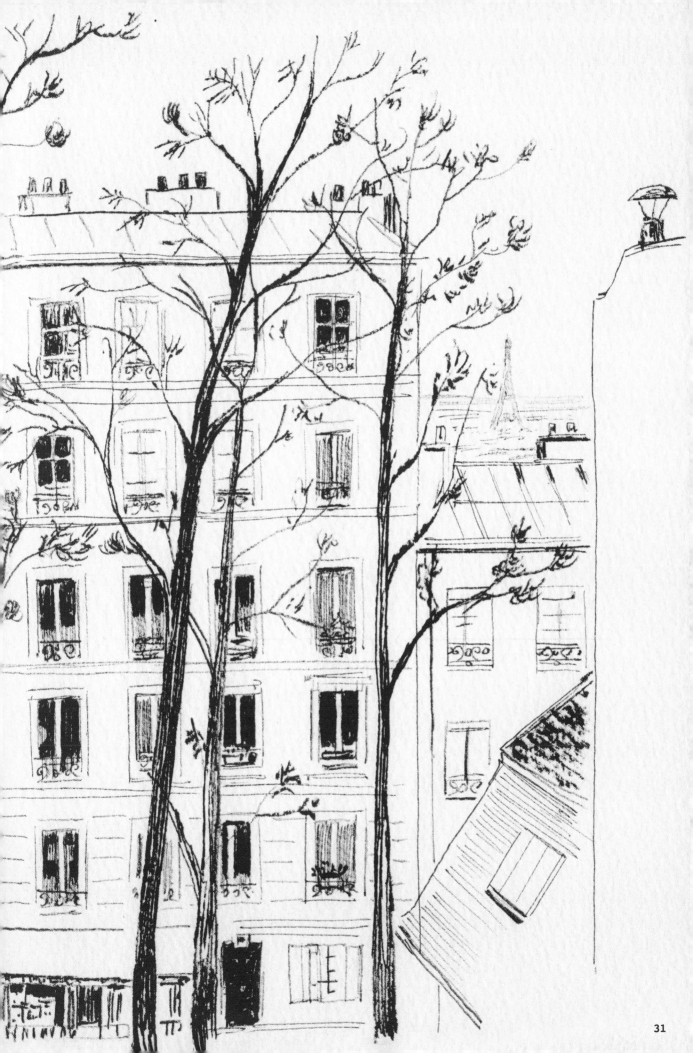

Ça c'est Paris...

LIBRAIRIE
PAPETERI

the Street

The streets of Paris have been described and depicted in words and pictures so vividly over the centuries that during a walk through the streets of Paris today it is almost impossible not to be reminded of images from the past.

A couple laughing at a café table might look for a moment like a Brassaï photograph, a dilapidated building in a back street can be half-seen through the lens of Atget, and the sensation of stepping from the rain into a warm café can make you feel like a character from a Hemingway novel.

I find this delicious blend of the modern and the past in Paris one of its most magical characteristics. Here, there seems to be a highly civilised balance between embracing the new and avant-garde and protecting the structure and mythology of what has gone before.

Paris is divided physically by the Seine into the Rive Gauche and Rive Droite, and also into 20 districts or arrondissements that spiral out clockwise from the 1st at its centre to the 20th in the east. Each area has its own discernible character and atmosphere reflected in the architectural fabric of the streets and their diverse cast of characters. Surrounded by the hurtling traffic of the périphérique, Paris is a world unto itself.

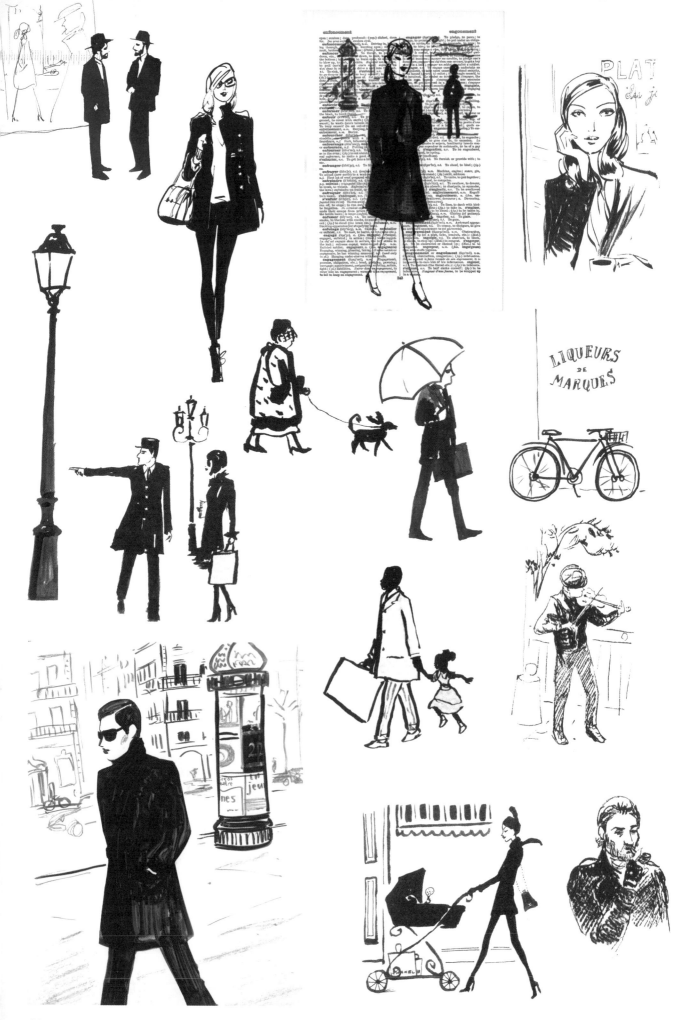

'In Paris
everyone wants
to be an actor
nobody is content
to be a Spectator'

Jean Cocteau

In Paris
everyone wants
to be an actor
nobody is content
to be a Spectator.

Jean Cocteau

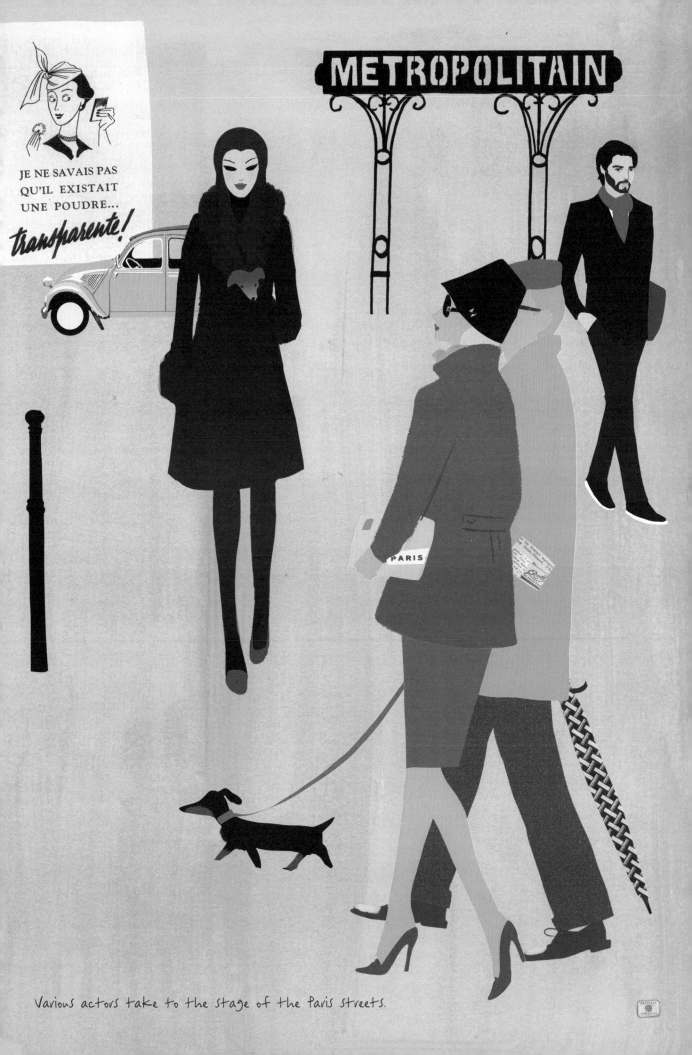

METROPOLITAIN

Various actors take to the stage of the Paris streets.

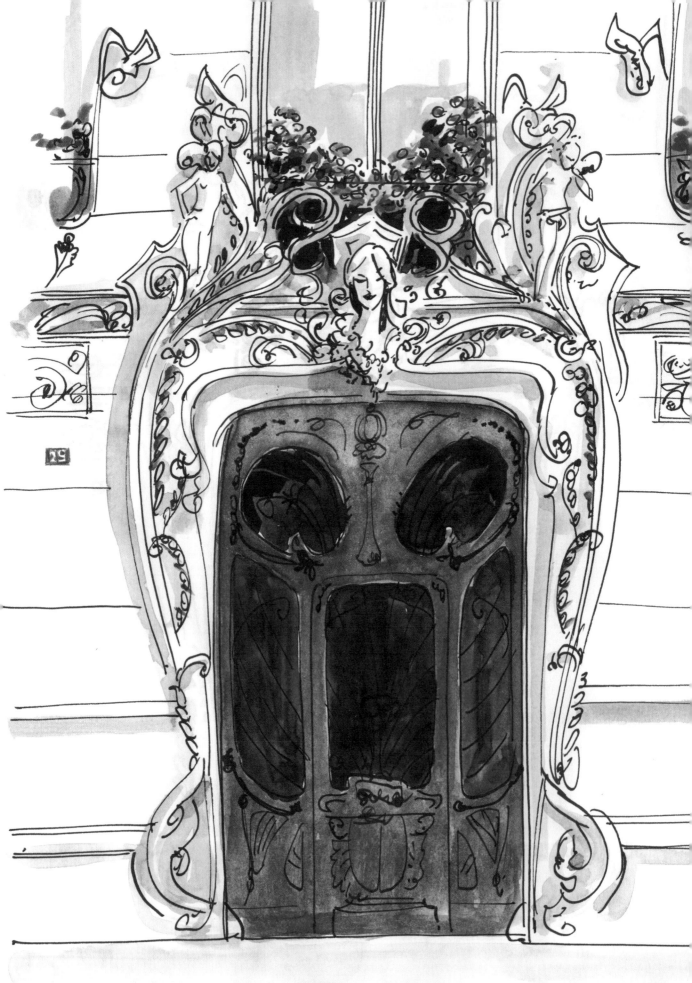

I stopped to draw the doorway of this amazing Art Nouveau apartment building on the Avenue Rapp.

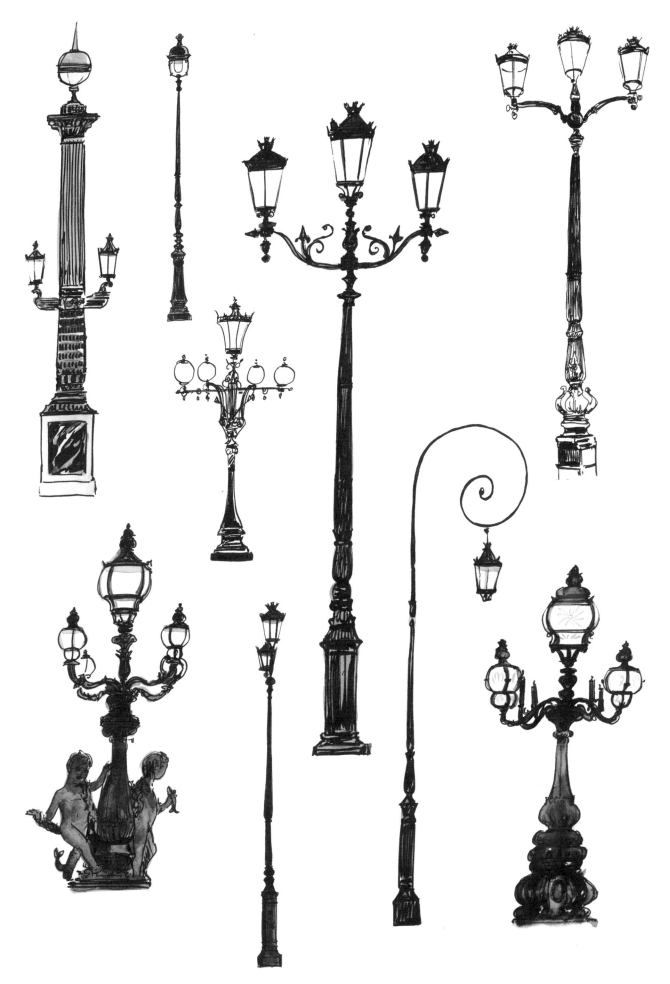

The streetlamps of Paris reflect something of its character:
varied, refined, elegant and eccentric.

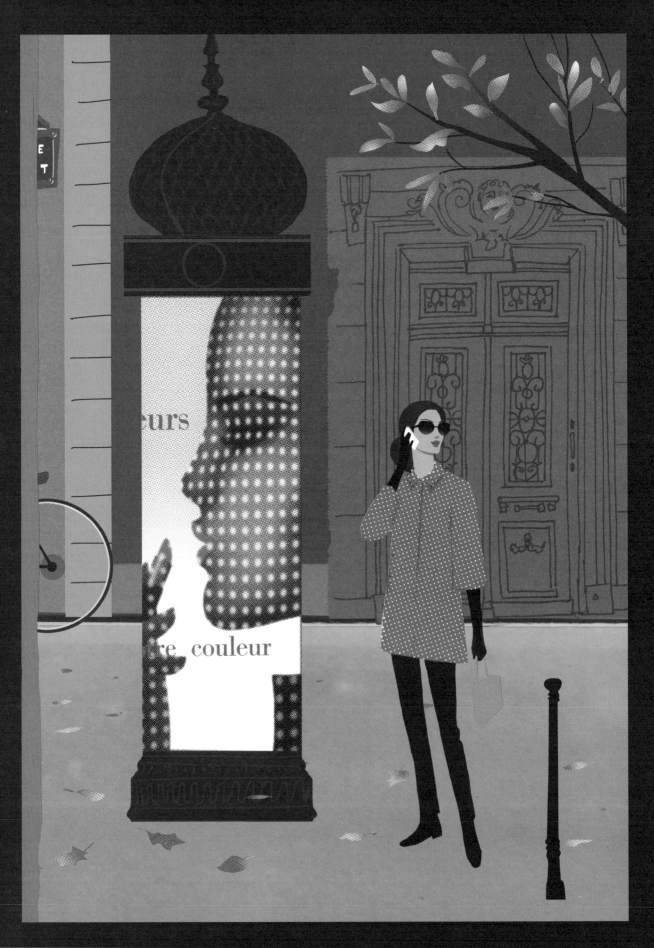

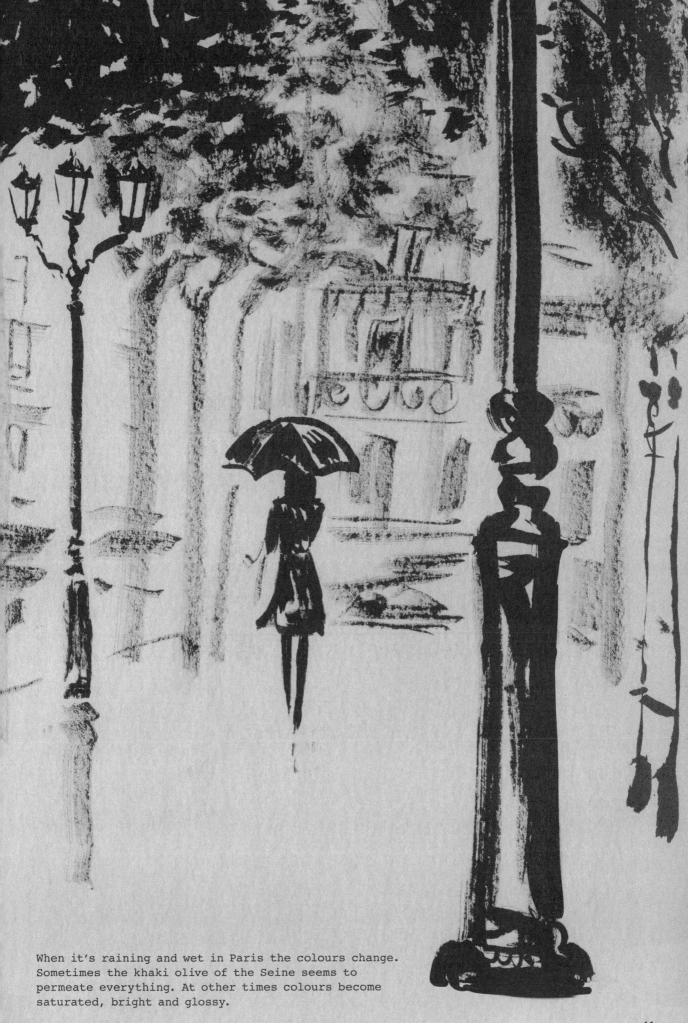

When it's raining and wet in Paris the colours change.
Sometimes the khaki olive of the Seine seems to
permeate everything. At other times colours become
saturated, bright and glossy.

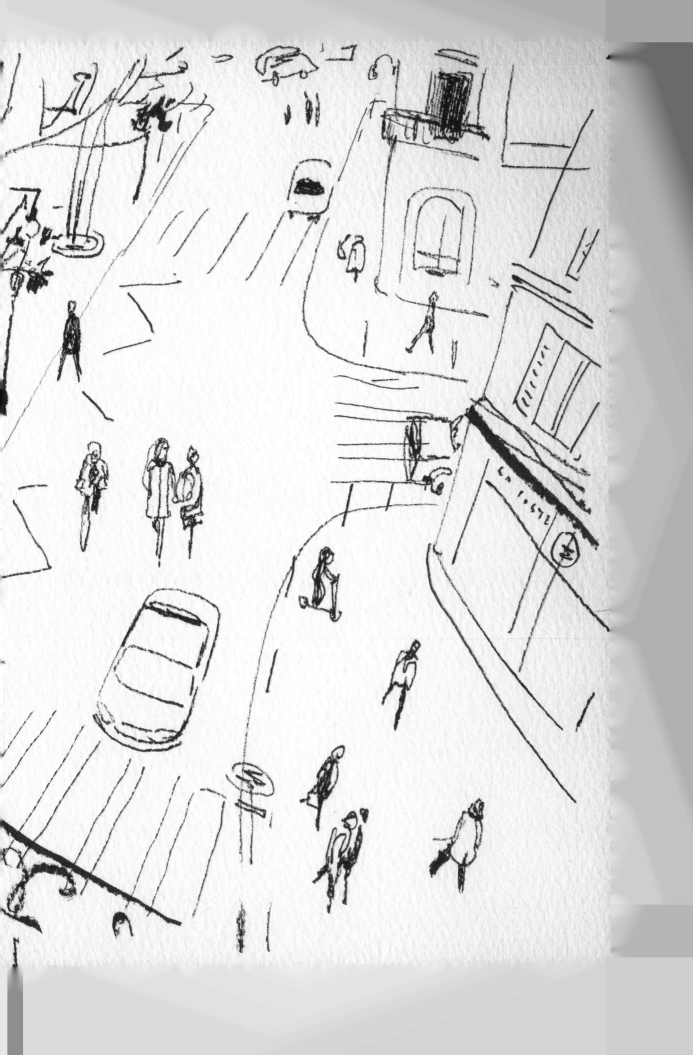

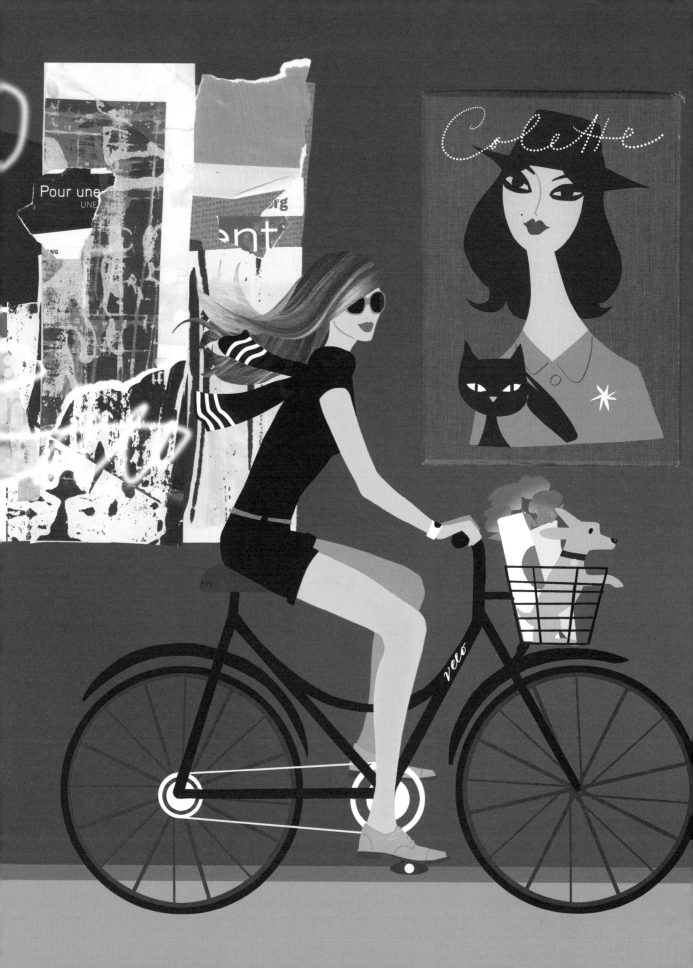

Brigitte on her bike. The Colette poster is not related to the shop —
she is an imaginary Parisian Eleanor Rigby alone with her cat. I found
the fragments of poster south of the river, near the Sorbonne.

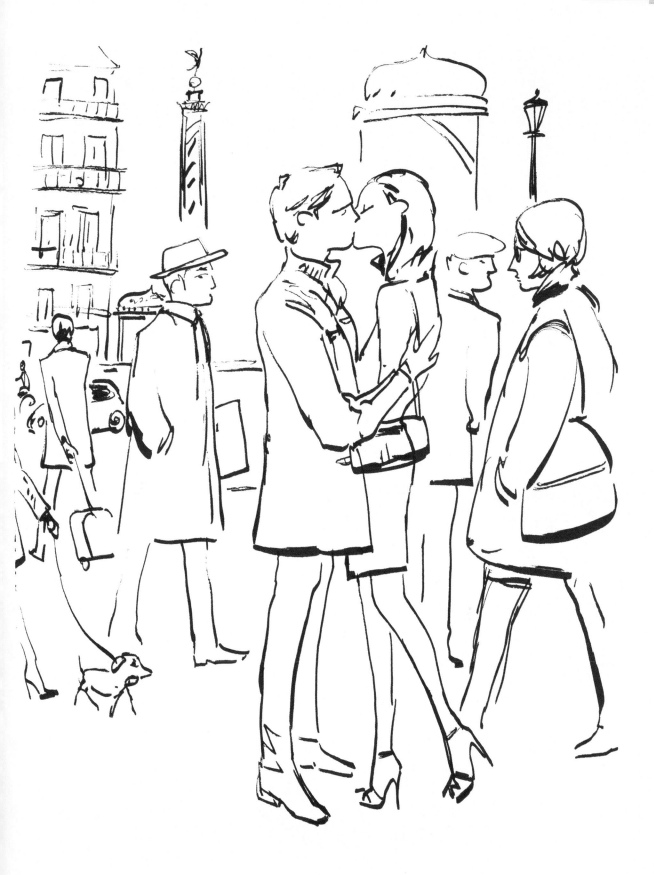

A couple stopped to kiss in the crowd, and for a moment it looked just
like the famous Robert Doisneau photograph.

45

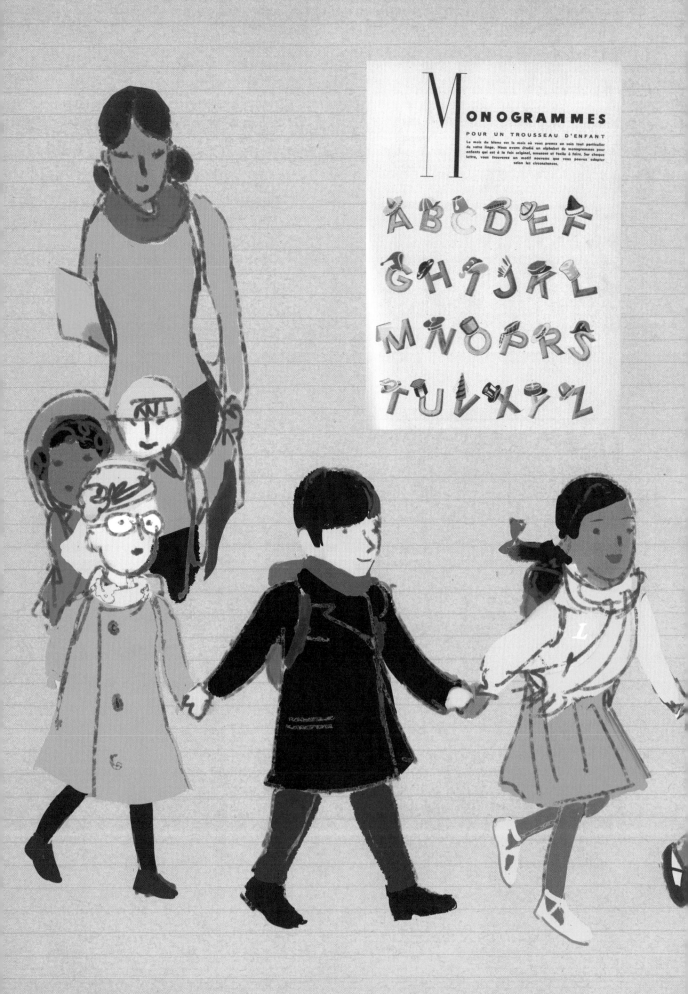

Crocodiles of schoolchildren holding hands brighten the streets of Paris.

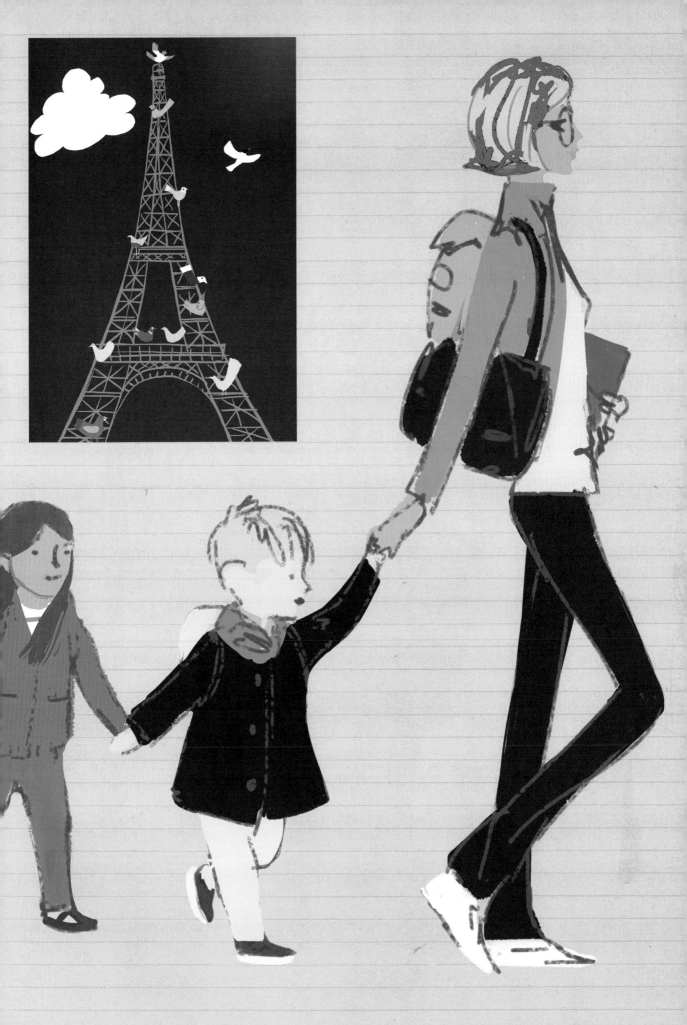

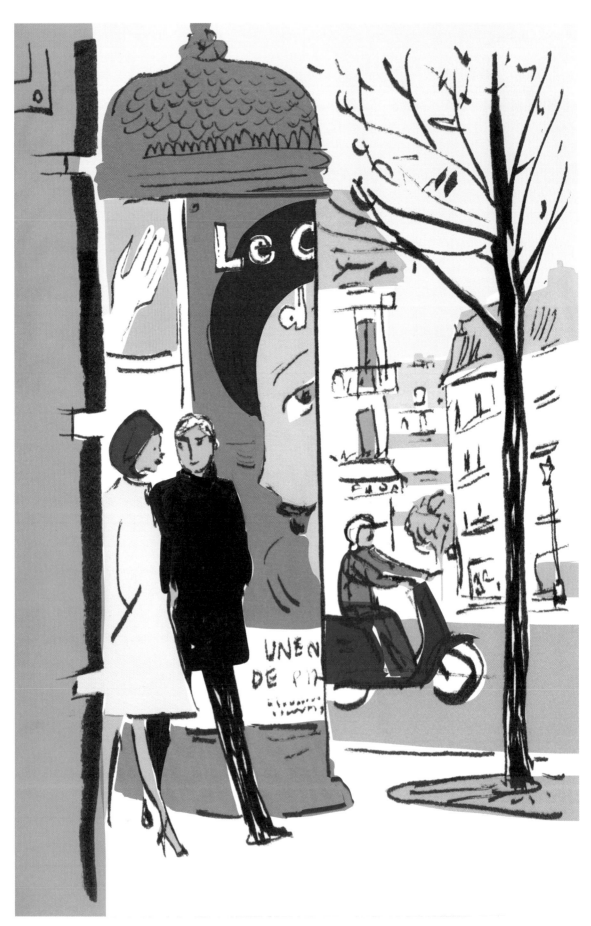

Sometimes I wake up and see a complete picture in my mind.
If I am quick I can make a sketch before it begins to fade.

PATISSERIE

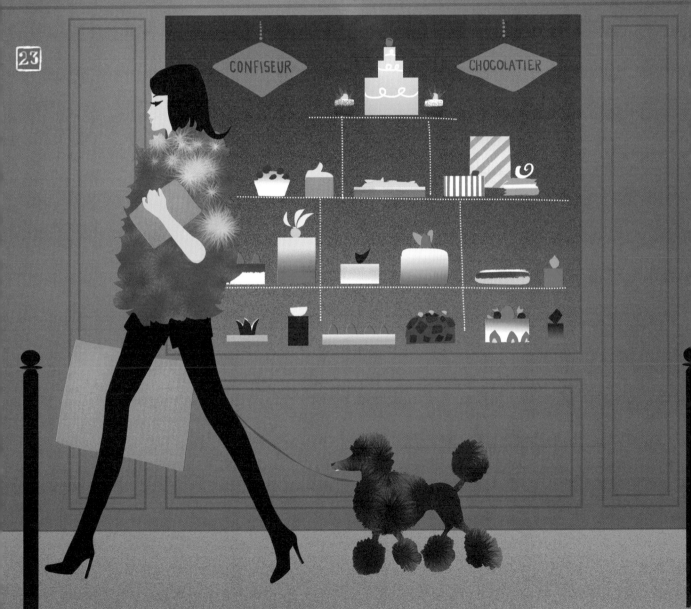

CONFISEUR

CHOCOLATIER

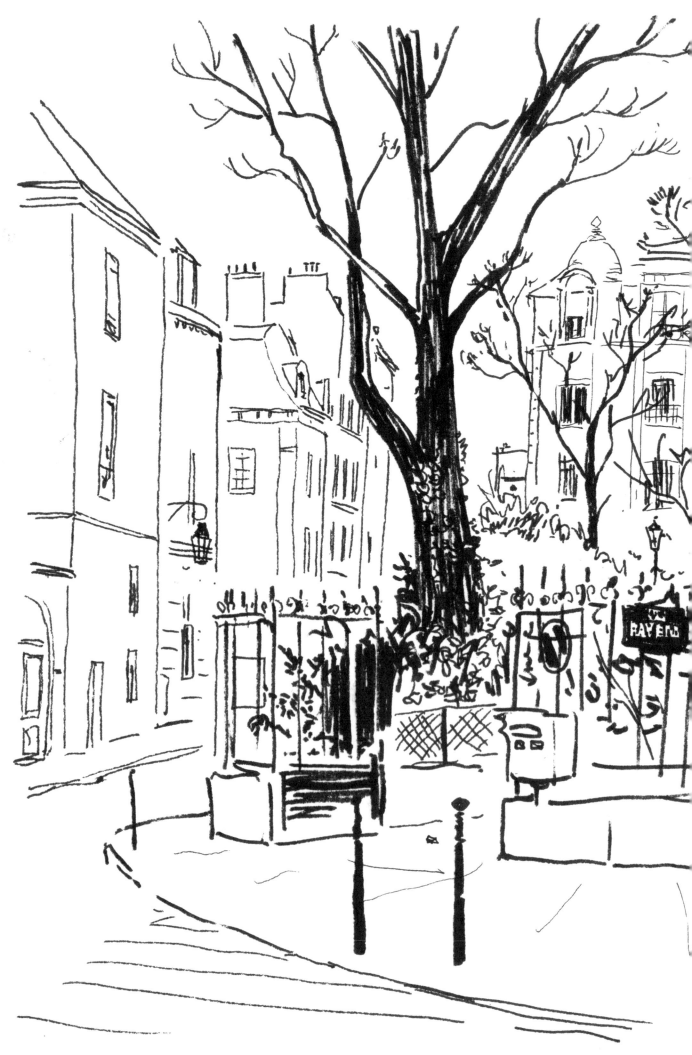

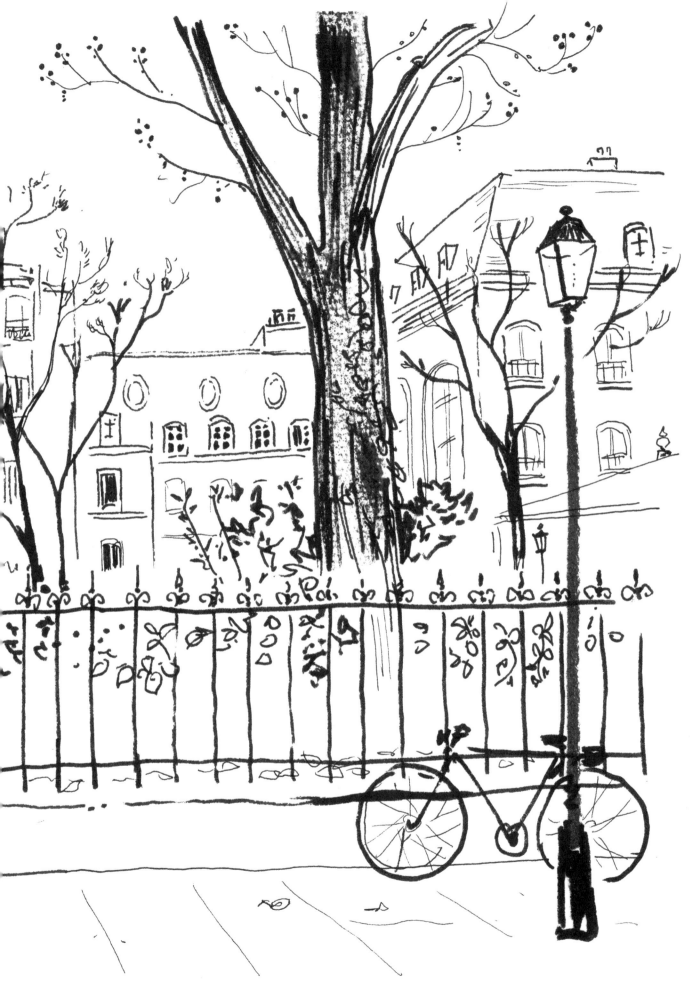

Le Sévigné in the Marais is a picture-perfect café from a film set.
This is the view of the Rue Payenne from an outside table in autumn.

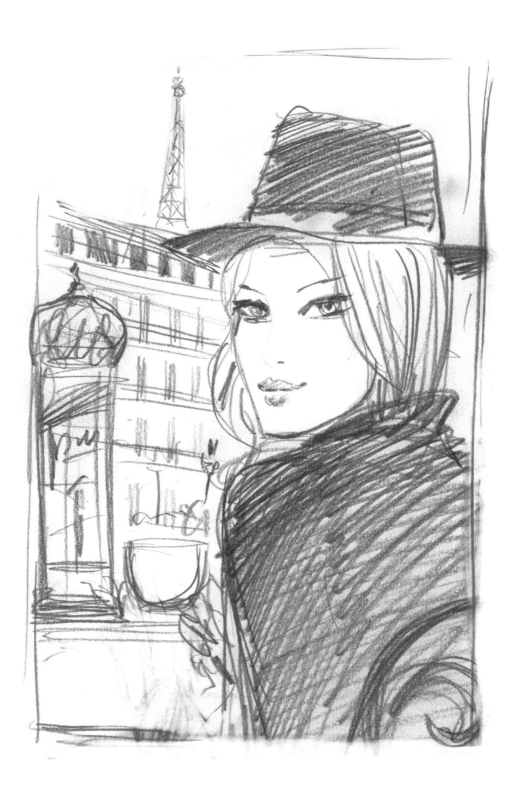

Le Café

Paris's cafés, bistros, brasseries and restaurants are like time capsules where laughter, cigar smoke and conversation seem to be held captive in their fabric of marble counters, bentwood chairs and tiled floors.

The classic iconography of smartly turned-out waiters, upturned glasses on paper tablecloths, chalkboard menus, the male and female salt and pepper and old gold typography picked out in reverse on lace-curtained windows are so many seemingly unchanging details that serve as reminders of all those who have sat here before. In a Parisian café these might include Jean-Paul Sartre, Simone de Beauvoir, Gertrude Stein, Brigitte Bardot, Hemingway or Picasso.

Cafés have long been the meeting point for Paris's cultural and intellectual elite. They made their first appearance as coffee houses in the 17th century, and as the popularity of this novel drink spread across Europe from the Ottoman Empire so did the enthusiasm for these new venues. Coffee houses and later, cafés, provided a neutral space, free of censorship and away from domestic life where ideas, news, gossip and entertaining conversation could be exchanged freely.

Many of Paris's cafés are now almost as famous as their celebrated patrons, including Café de Flore, Les Deux Magots and Brasserie Lipp. To take a table at a Paris café with your morning petit noir and croissant while watching the city wake up around you is one of life's great pleasures, and with their continually changing theatre and supply of good things to eat and drink I find them the perfect place to sit and draw.

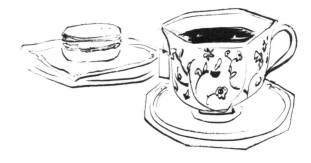

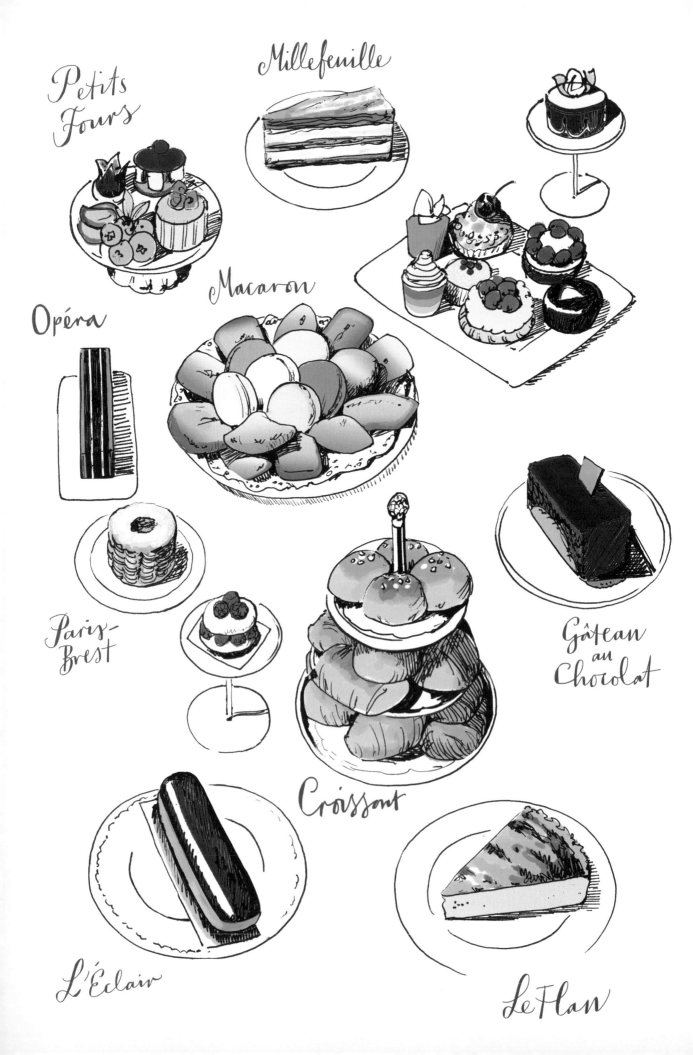

Petits
Jours

Millefeuille

Opéra

Macaron

Paris-
Brest

Croissant

Gâteau
au
Chocolat

L'Éclair

Le Flan

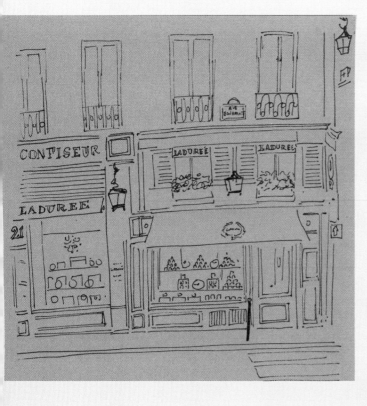

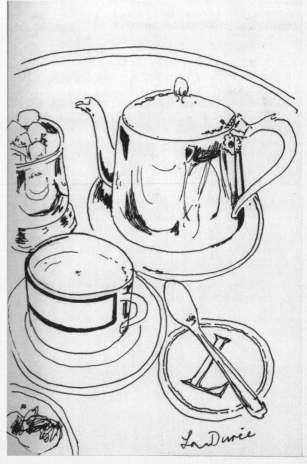

Above: Ladurée is famous for its multi-coloured and flavoured macaroons. I recommend the caramel au beurre salé (salted caramel), a classic Parisian flavour combination.

Opposite: An assortment of well-known pastries and cakes.

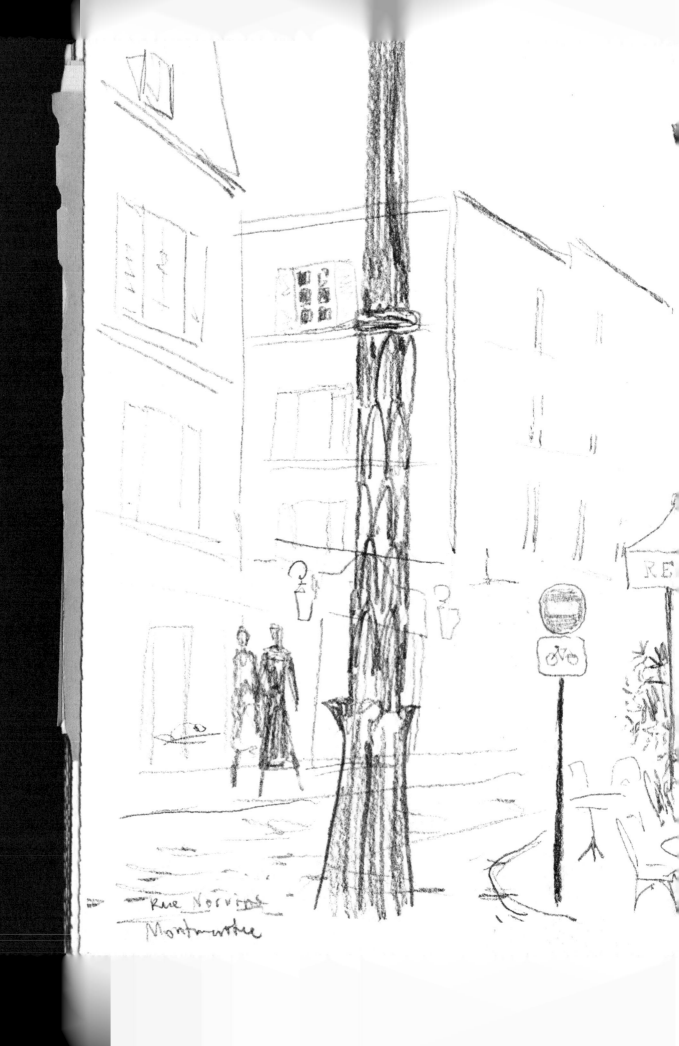

Rue Norvins
Montmartre

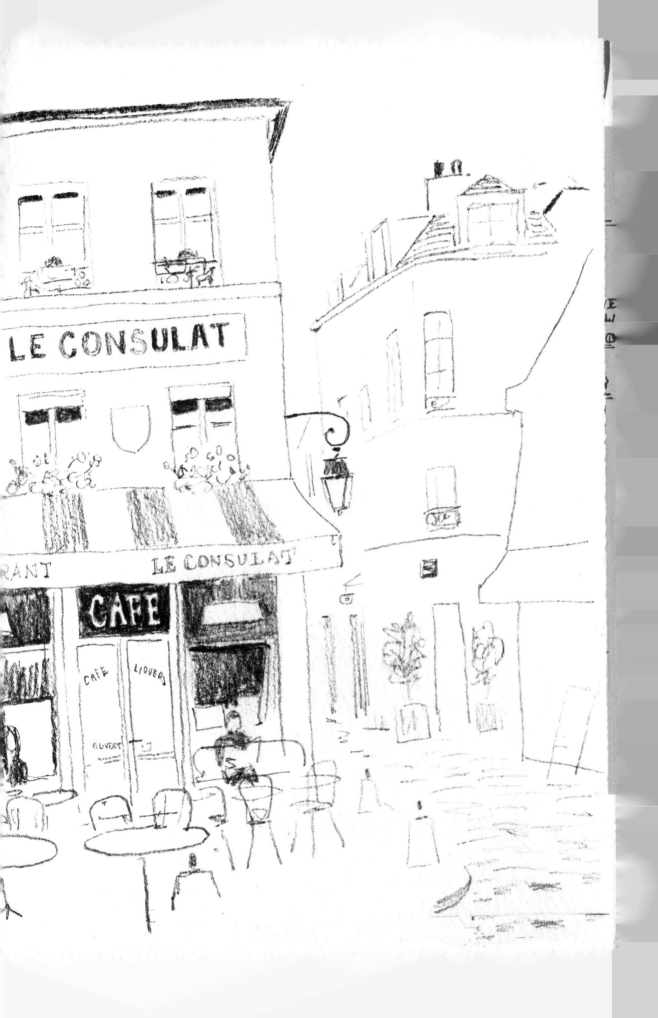

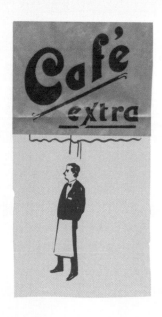

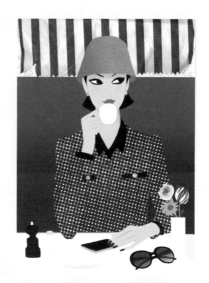

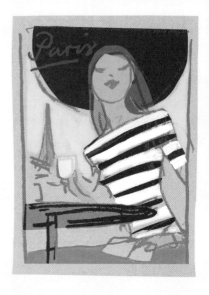

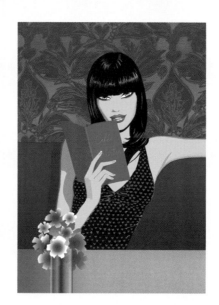

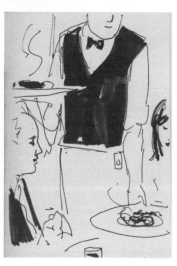

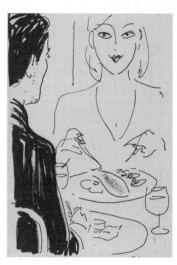

Above: Little sketches and pictures on the theme of eating out in Paris.

Opposite: Chez Julien on the Rue du Pont Louis-Philippe is another impossibly perfect Parisian-looking restaurant.

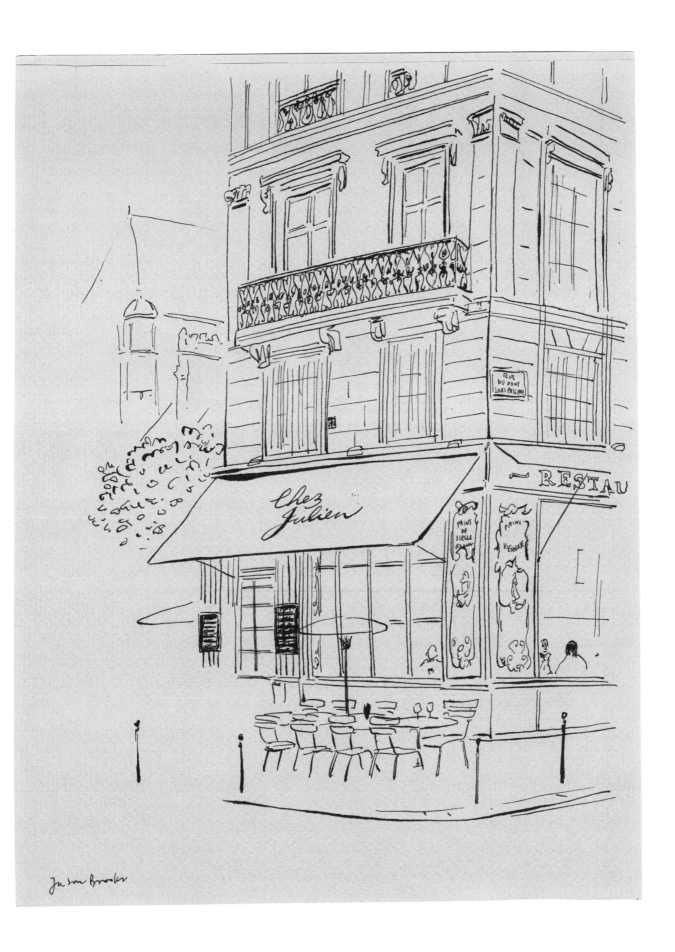

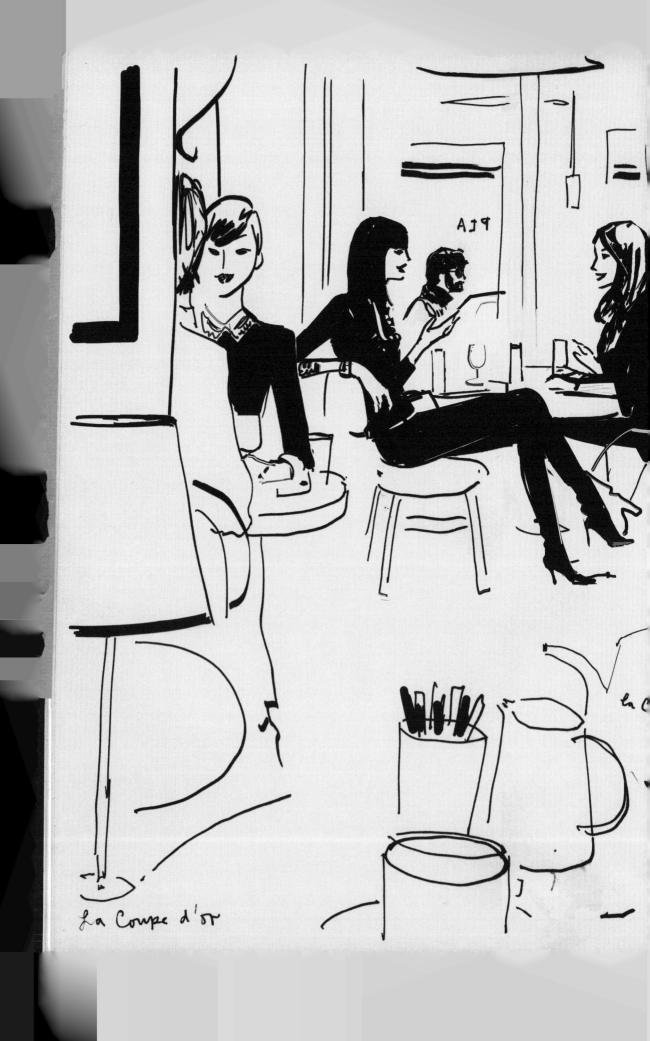

La Coupe d'or

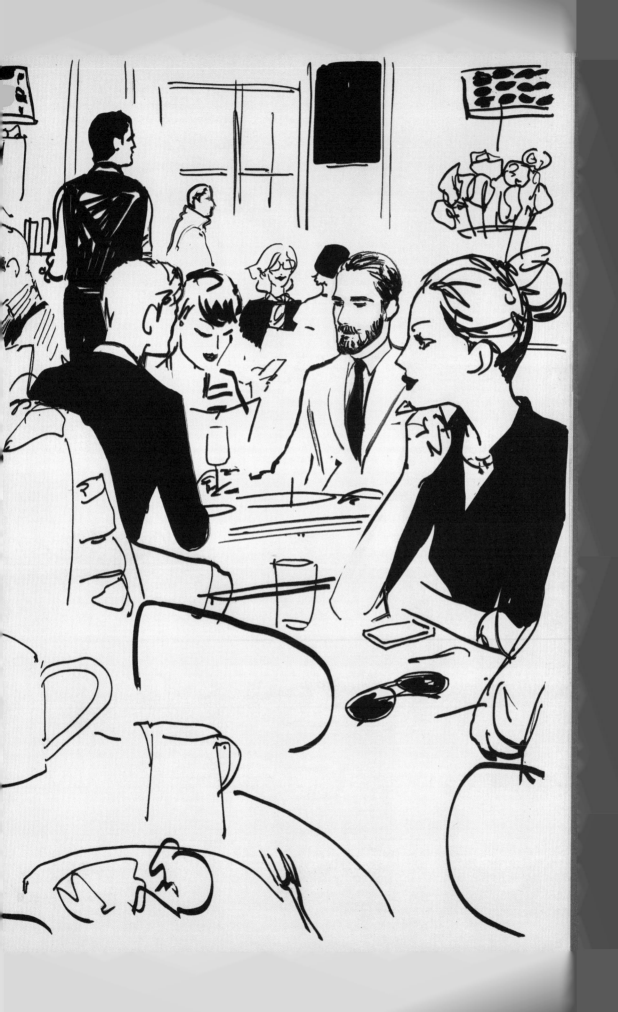

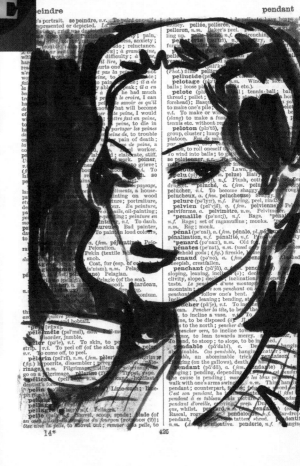

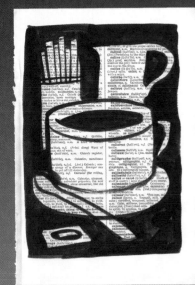

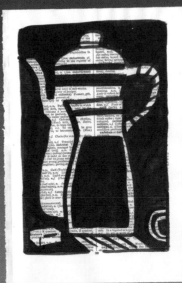

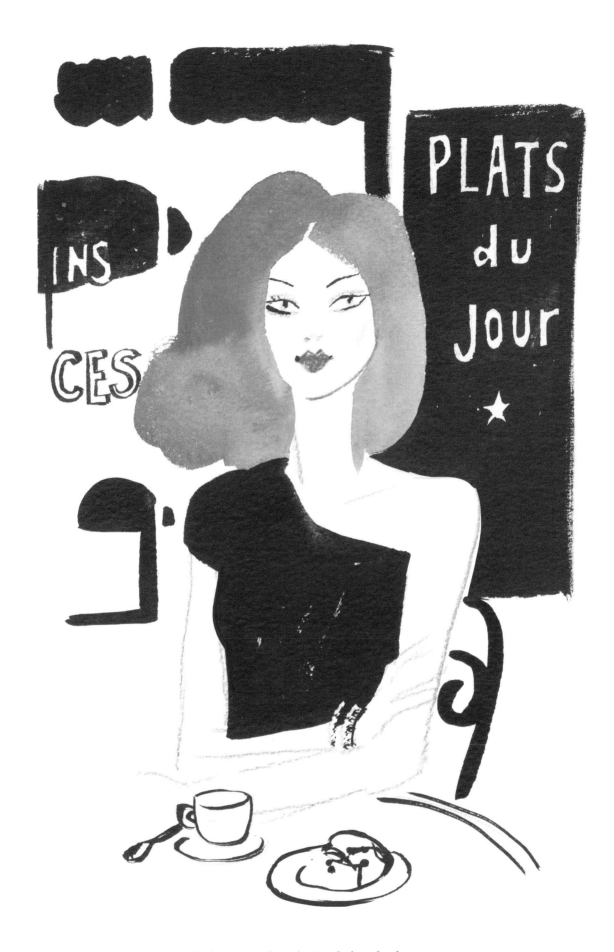

Above: A certain shade of red hair is a classic Parisian look.

Opposite: Café pictures on old French dictionary pages. The water carafe and glass are in a style seen all over Paris. The corkscrew silhouette is based on one in Miró's studio.

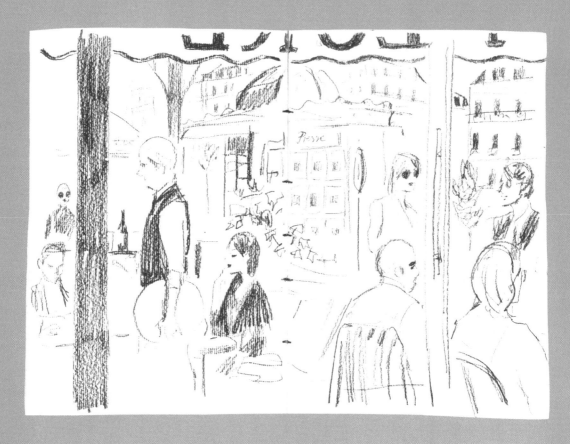

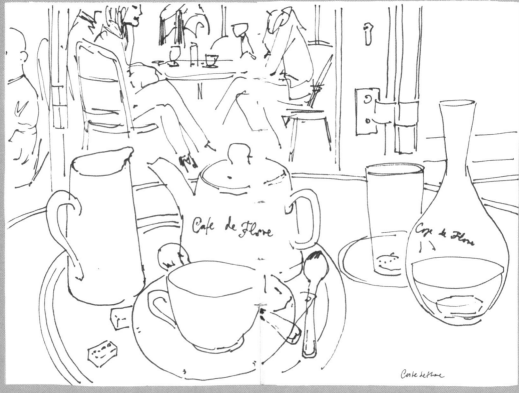

Above: The Café de Flore on the Boulevard St-Germain is among the most famous of all Paris cafés. The drawing at the top is the view today from a similar vantage point to the famous Jeanloup Sieff photograph — my favourite table.

Opposite: Bistro still life in blue.

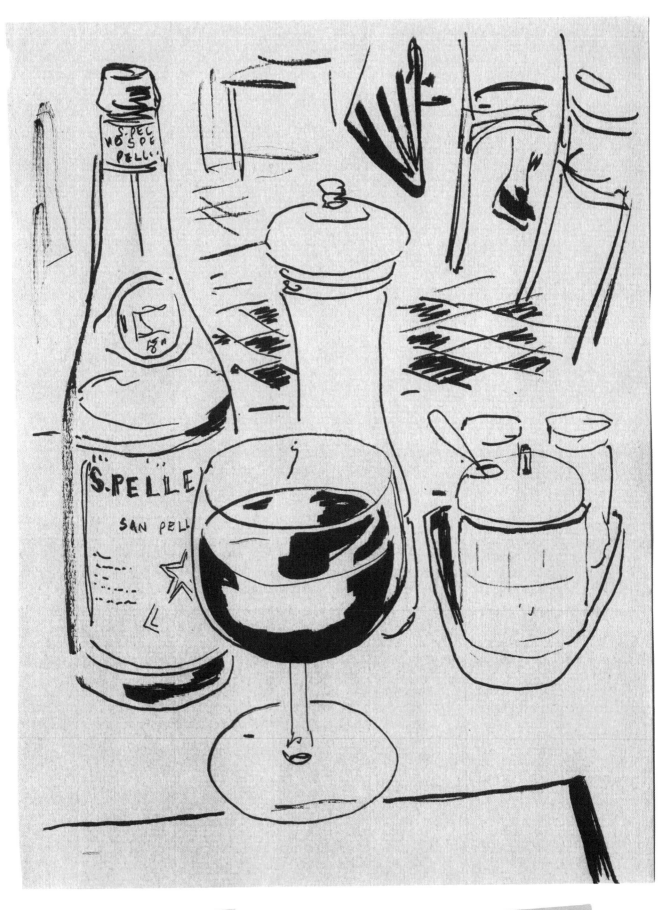

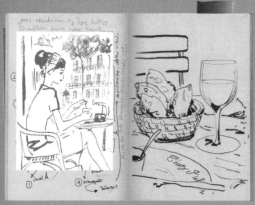

chez Julien

chez camille

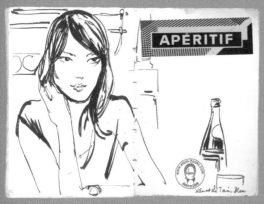

Nila at Le Train Bleu

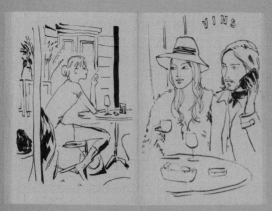

Le Sancerre

Le Select

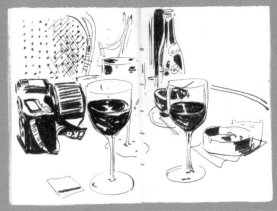

café Le Nemours

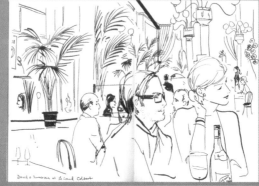

David, Francesca, Avril and Tony at Le Grand colbert

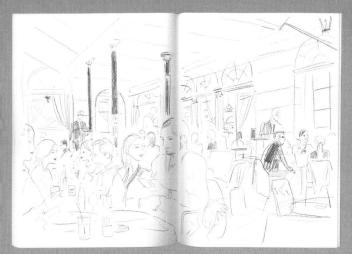

café costes

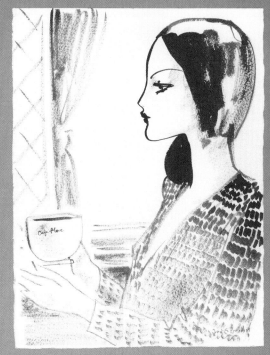

café de Flore

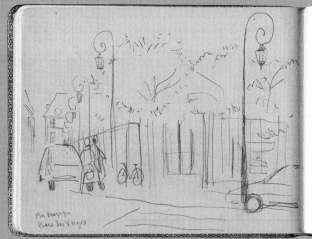

Ma Bourgogne

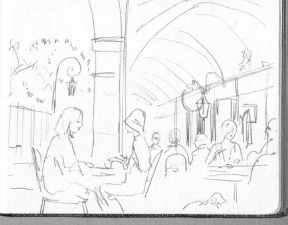

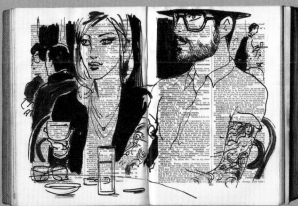

Pharamond

oui!

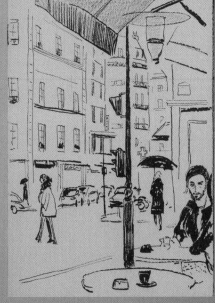

Paris's cafés, restaurants and
bistros are great places
to sit and draw. These are
some of my favourites.

Le pick-clops

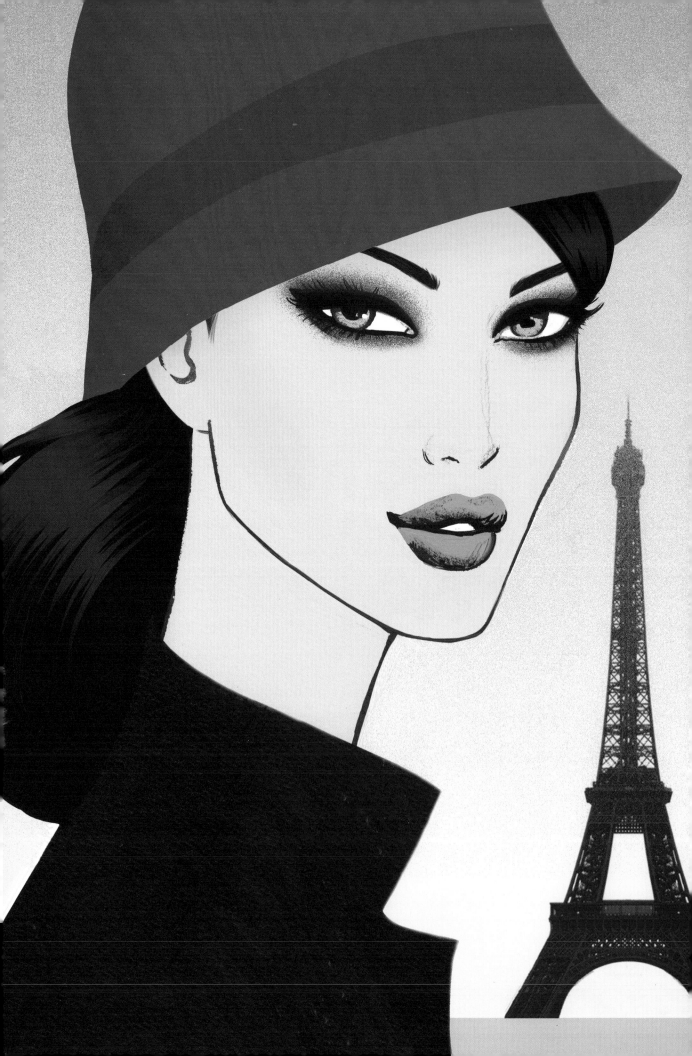

Fashion

Paris is the birthplace of many of the world's greatest and most enduring fashion houses and has immortalised the names of some of their founders, including Coco Chanel, Yves Saint Laurent, Christian Dior, Hubert de Givenchy and Louis Vuitton. Today it is easy to forget that these powerful global brands were started here in small boutiques, studios and workshops, the product not only of innovative and entrepreneurial individuals but also of generations of immensely skilled artisans and craftspeople.

Although clothes designed in Paris today may often be made abroad, these traditions continue, particularly in the world of haute couture, where the number of hours that might go into producing a single garment can be astonishing. As an illustrator just starting out, I worked for several seasons at the Paris couture shows, which served as a unique apprenticeship and gave me insight and access into this rarefied world of sumptuous one-off creations tailored for a very select clientele.

From couture and ready-to-wear fashion to street trends, Paris fashion influences and inspires what people wear around the world. Here, fashion is a kind of social game which Parisians are very adept at playing, and it's often about knowing what the rules are in order to subvert or personalise them. Appearances are important in Paris, whether that takes the form of chic conformity or dazzling innovation.

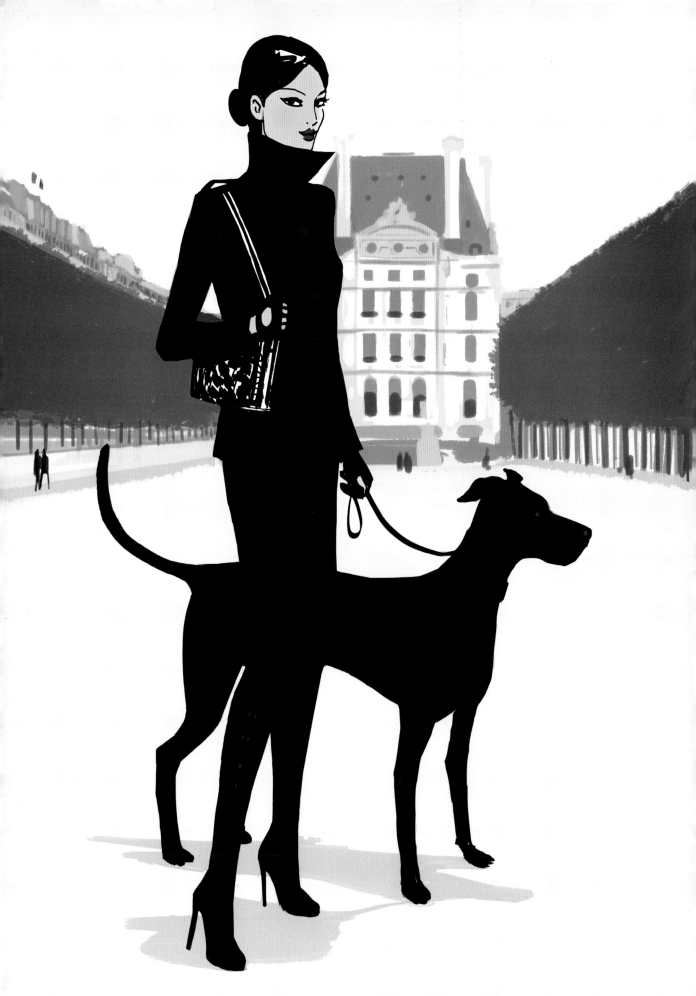

Silhouette style in the Jardin des Tuileries.

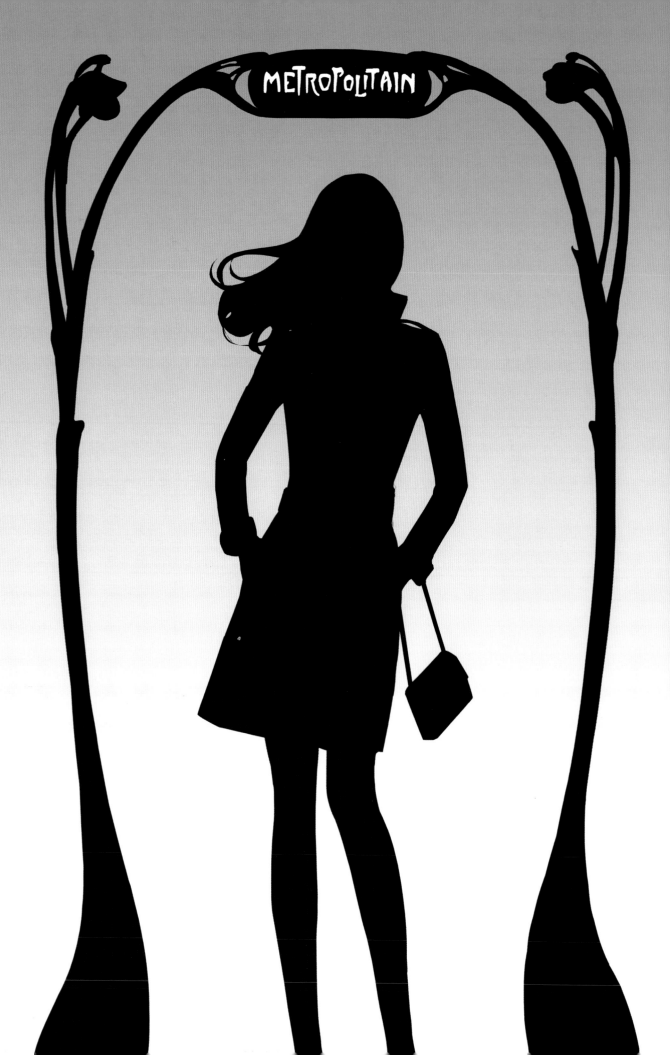

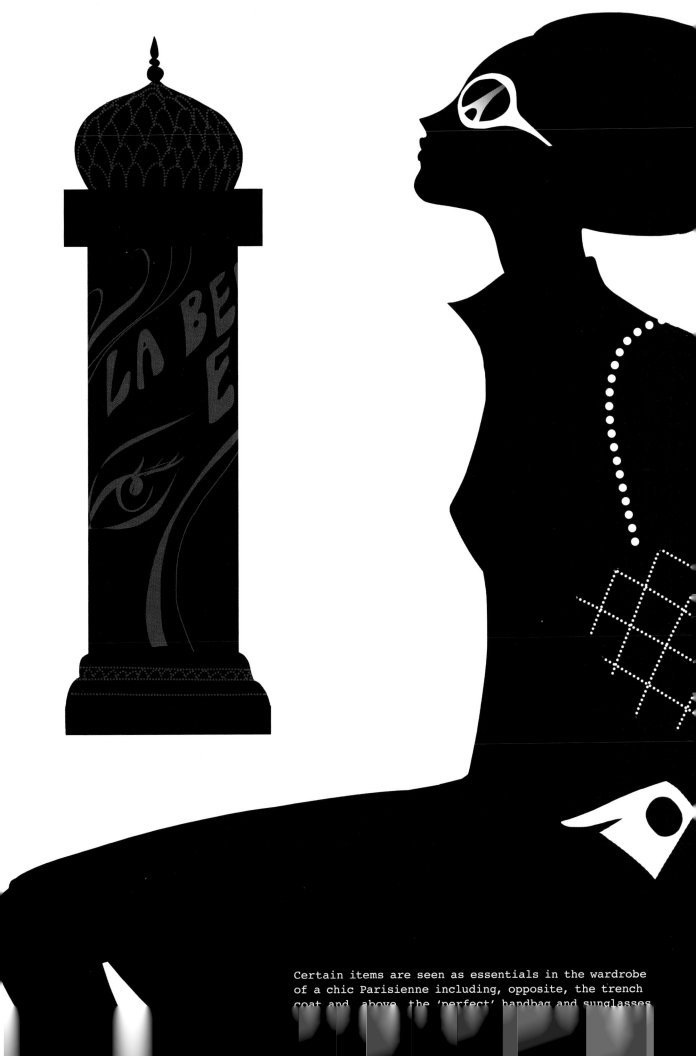

Certain items are seen as essentials in the wardrobe of a chic Parisienne including, opposite, the trench coat and, above, the 'perfect' handbag and sunglasses.

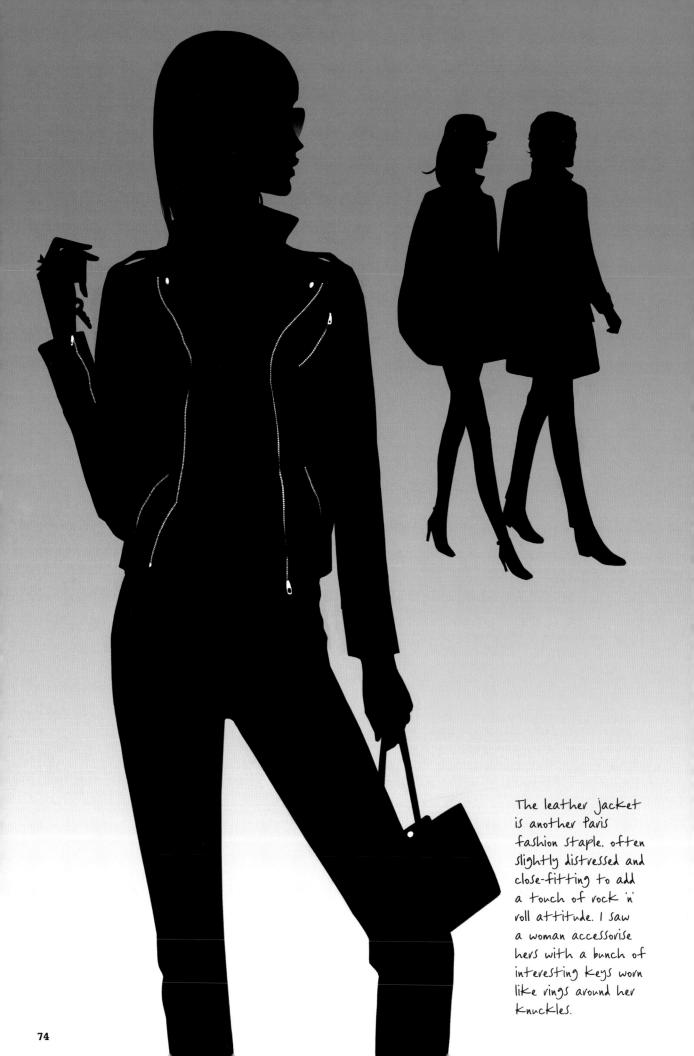

The leather jacket
is another Paris
fashion staple, often
slightly distressed and
close-fitting to add
a touch of rock 'n'
roll attitude. I saw
a woman accessorise
hers with a bunch of
interesting keys worn
like rings around her
knuckles.

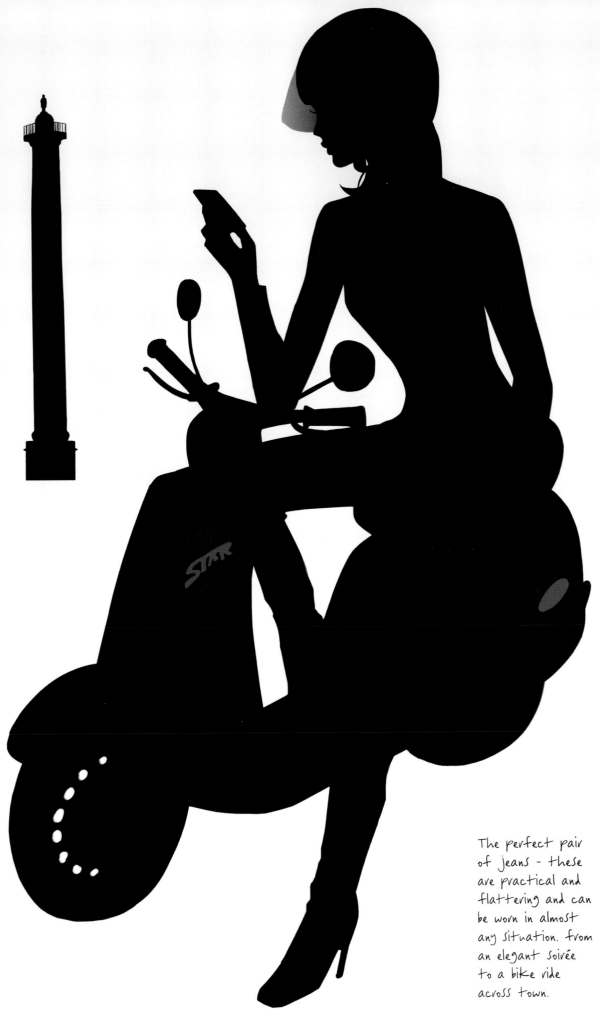

The perfect pair
of jeans - these
are practical and
flattering and can
be worn in almost
any situation, from
an elegant soirée
to a bike ride
across town.

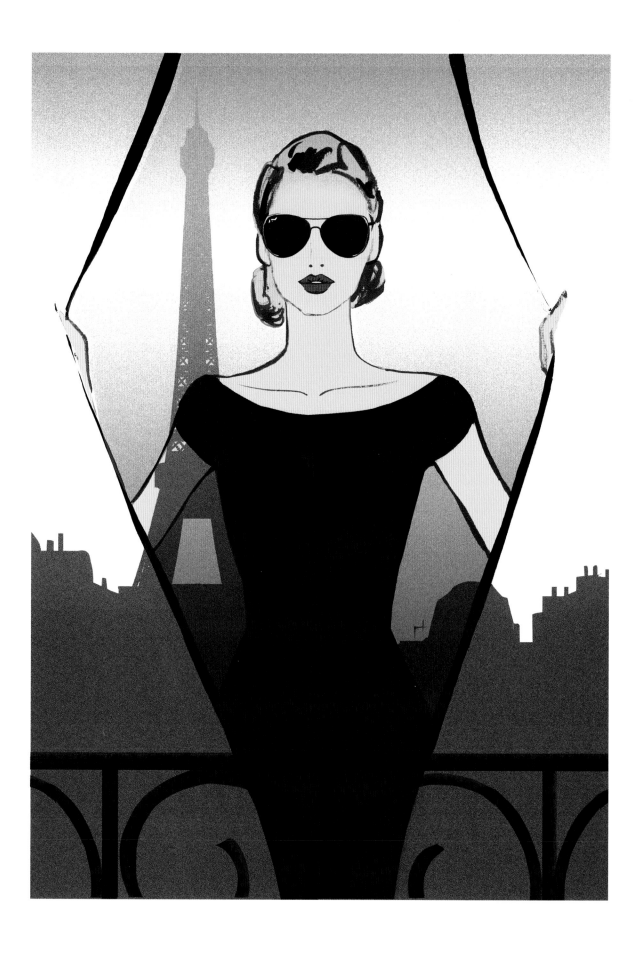

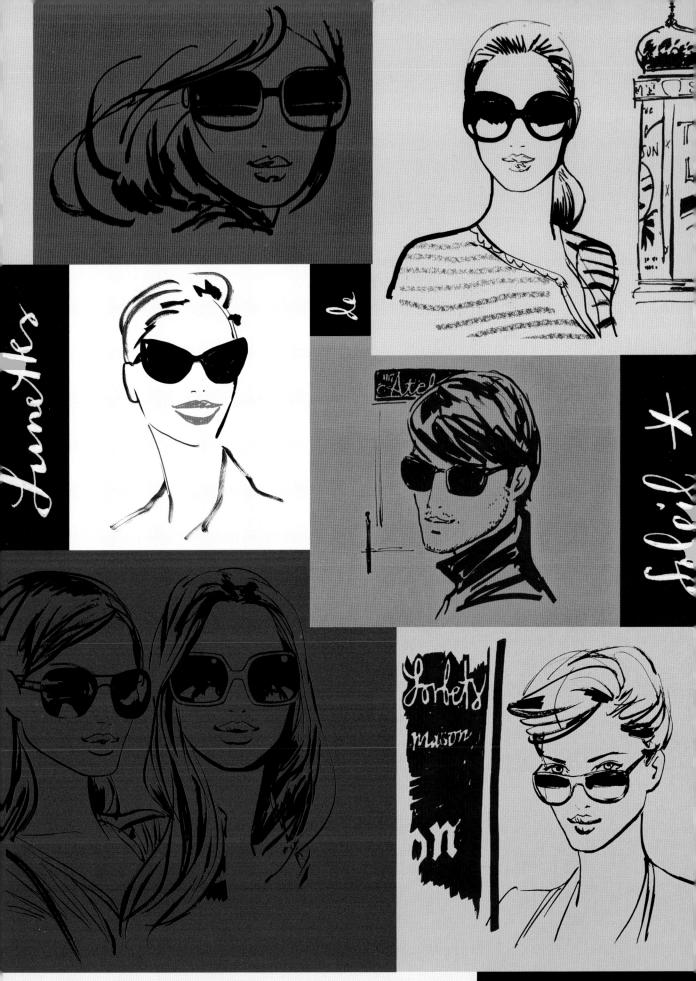

In Paris, accessories of all kinds, such as sunglasses, are a way of showing individuality and personal style.

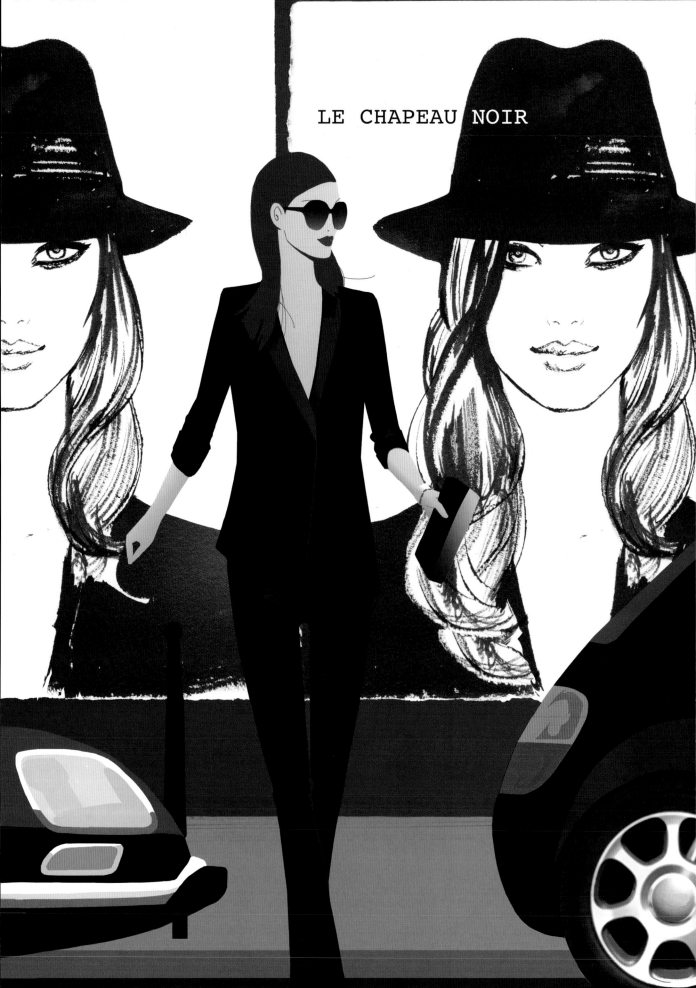

LE CHAPEAU NOIR

Right: Painting on a French dictionary page inspired by a famous Norman Parkinson photograph which in turn clearly borrows from an earlier version of this image by the Paris-based painter Kees van Dongen.

Opposite: The adoption of traditionally masculine items of clothing by women has been a recurrent and influential theme in Paris fashion. Today, chunky men's watches, tuxedo jackets, trench coats and variations on the trilby hat are everyday items: originally menswear, they have come to epitomise Parisian chic when worn by women.

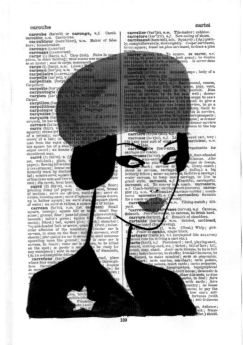

Paris fashion influences what is worn around the world.

After graduating from the Royal College of Art, I worked for several seasons as an illustrator reporting at the Paris Couture Week for a London newspaper. It was an entrée into another world and an extraordinary apprenticeship in the workings of the highest of high fashion. With sketchbook in hand I was able to perch next to Valentino at the Ritz during fittings, see Lacroix in his studio or Karl Lagerfeld backstage at Chanel. The shows were electric, dynamic pieces of theatre that could make the heart beat faster or move an audience to tears with their beauty. To experience all this as a young man left me spellbound and is an experience that has stayed with me ever since.

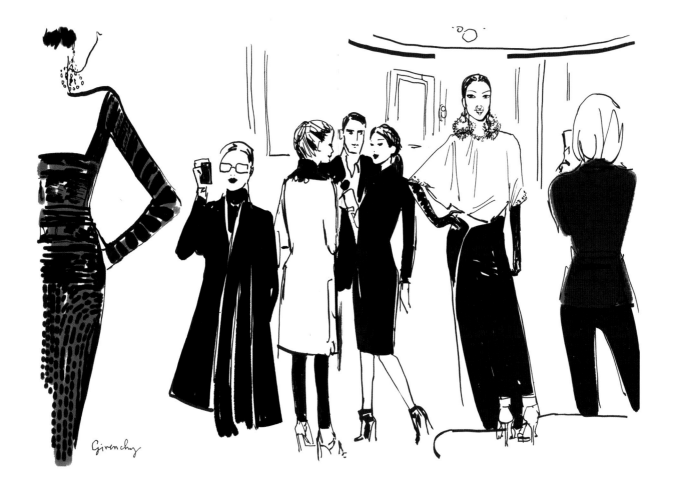

Givenchy couture at the Place Vendôme.

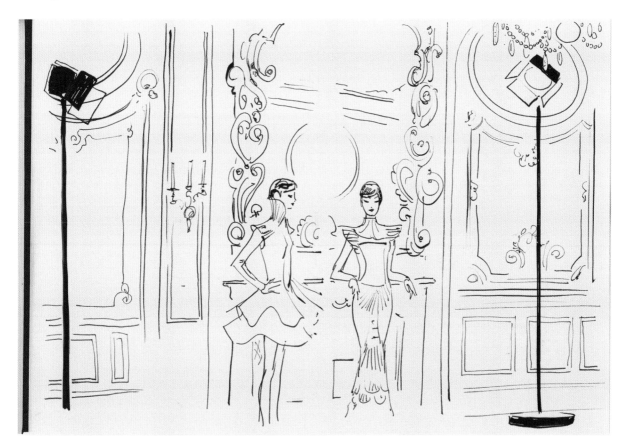

Worth couture in a grand salon on Avenue du Président Wilson.
Established in 1845, it was the city's first couture house.

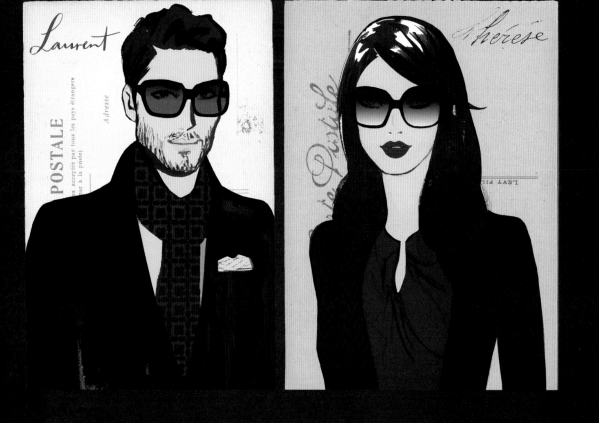

An invented Parisian couple 'à la mode'. I have
given them the names from Emile Zola's Paris-
based novel Thérèse Raquin.

Underground, the city is a labyrinth of
secret passages and vaults. Perhaps to be
truly glamorous, Paris needs a little darkn

'Paris does more than make the law, she makes fashion'

Victor Hugo

'Paris does more than make the law; she makes fashion.'

Victor Hugo

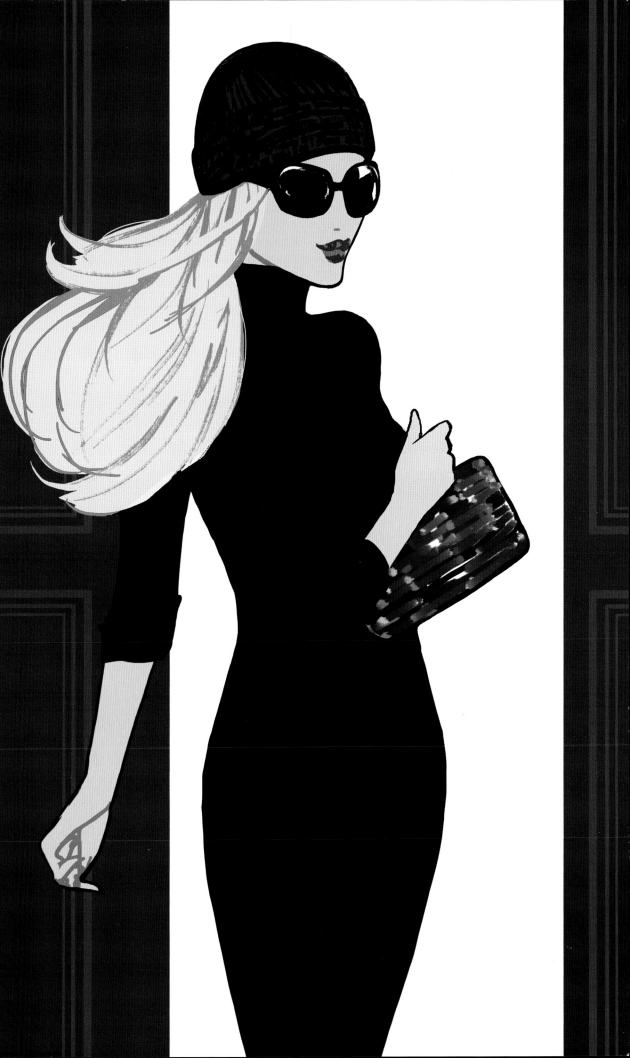

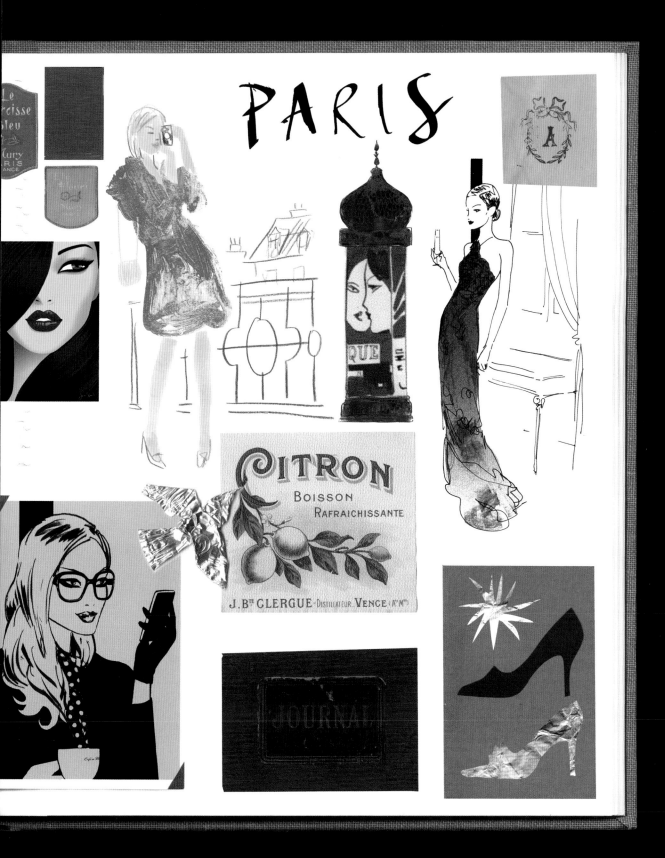

PARIS

Paris flea markets are a great place to discover old labels, fashion magazines and other bits of printed ephemera. On this page I've mixed some of these objets trouvés with my own Paris-inspired drawings. The silver foil dove was made from a cake tin while waiting at the Gare du Nord.

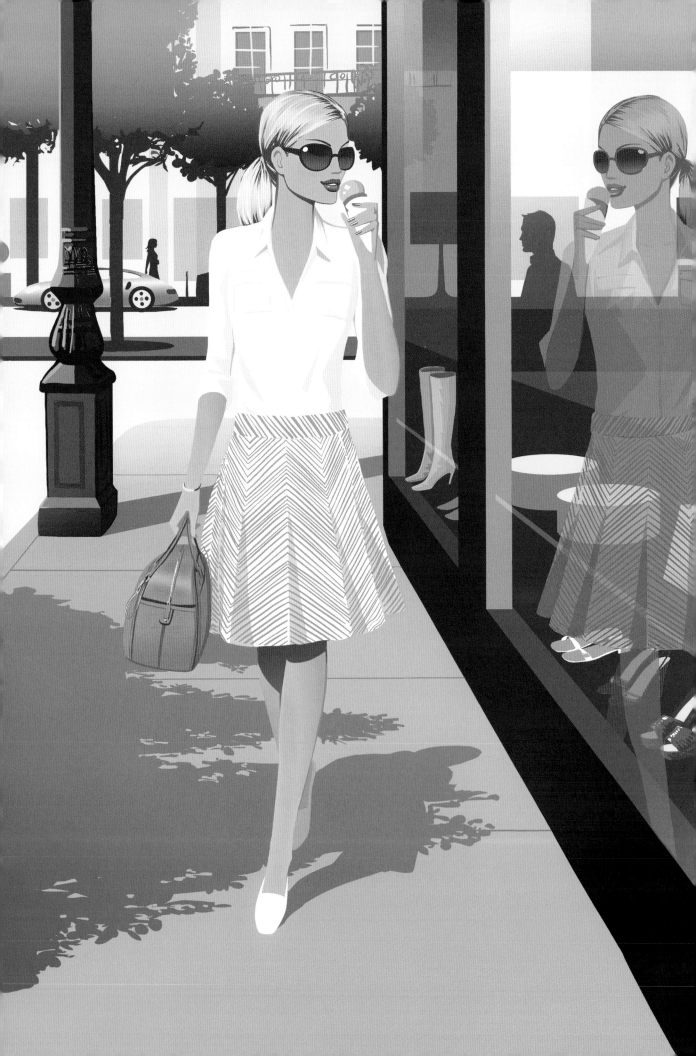

Shopping

The variety and quality of products of every kind available in Paris is extraordinary. Andy Warhol likened department stores to museums, and I think the same can easily apply to the shops of Paris. The sheer expertise and craftsmanship that lies behind so many of Paris's offerings is apparent everywhere. From high fashion boutiques and antique shops to the most humble patisserie, there is a level of taste and artistry displayed that is unique to Paris.

Shop windows here are an art form unto themselves, and an understanding of composition and colour seems to be at work everywhere. In the area around Rue St-Honoré and Avenue Montaigne, virtually every global fashion and luxury goods brand has a presence. Across the river, the Boulevard St-Germain and its surrounding streets are home to more global players as well as niche boutiques selling everything from antique picture frames and taxidermy to scented candles and flowers. The Marais and the area to the north is the site for trendy new brands, and the flea markets of Paris are a treasure trove for seekers of unique vintage objects.

Over the next few pages are a just a small selection of shops from around Paris: there are dozens more I would like to have included and, as with everything in Paris, always more to be discovered...

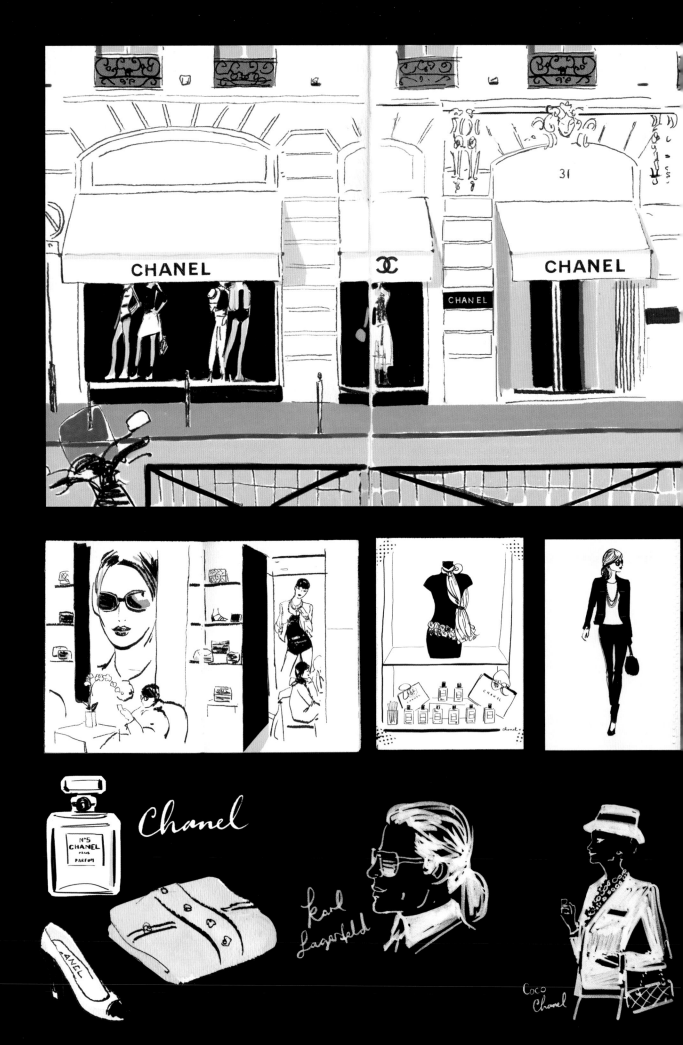

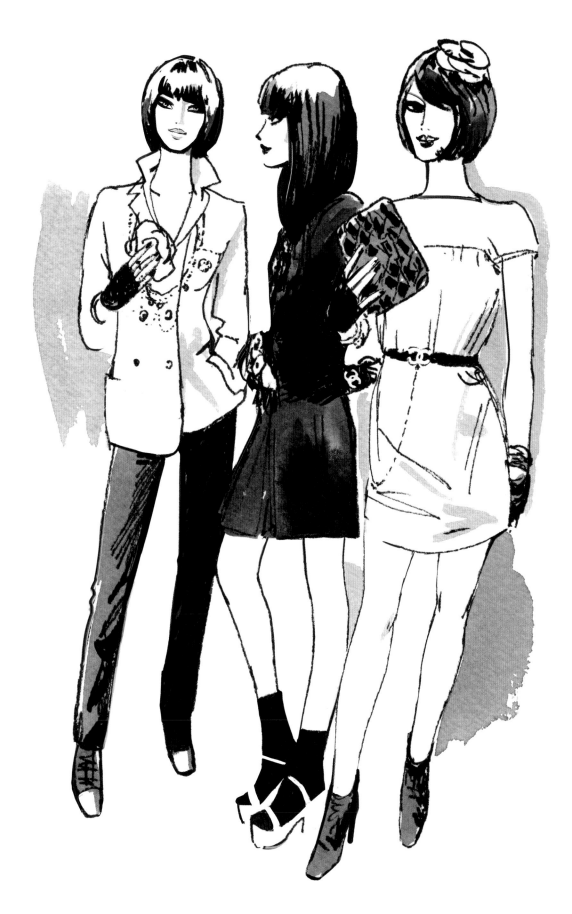

Chanel is perhaps the brand most associated with the glamour of Paris, and Coco Chanel revolutionised the way women dressed. Her apartments still exist above the 31 Rue Cambon Chanel store, opposite. Today, Karl Lagerfeld continues to develop the house of Chanel, reinventing the legend with each impeccable new collection.

Drawing at Lanvin, Rue du Faubourg St-Honoré, created in
1909, Lanvin was among the first modern fashion brands.

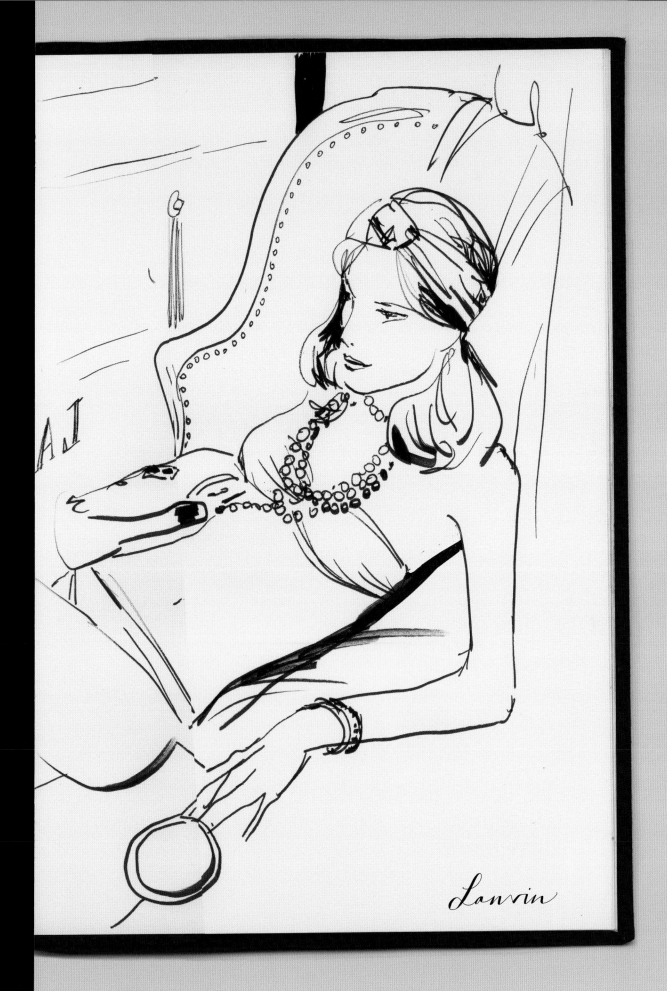

Lanvin

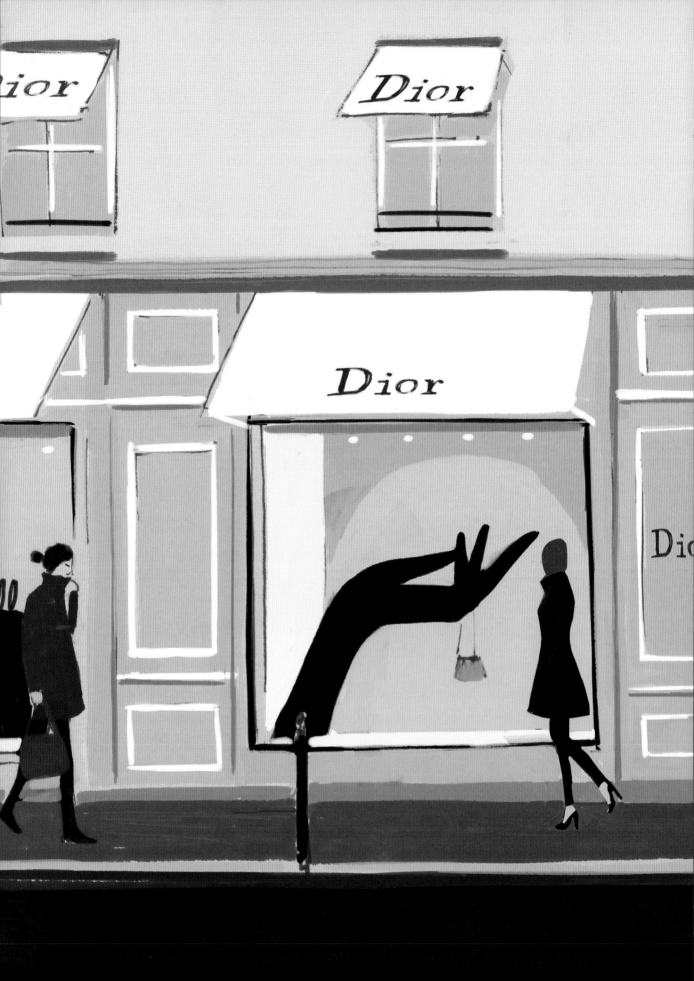

Founded by Christian Dior in 1946, the house of Dior is another of the great names of Paris fashion.

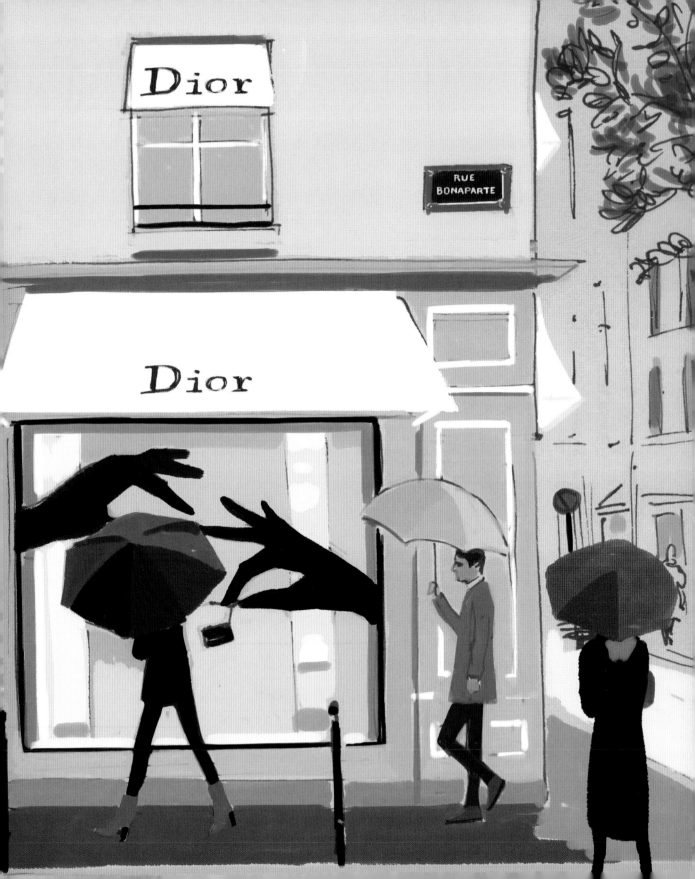

Astier de Villatte

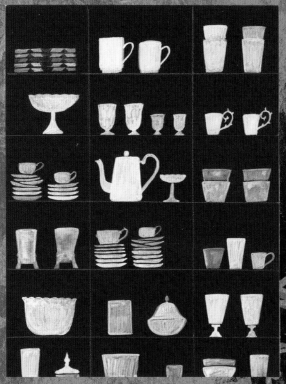

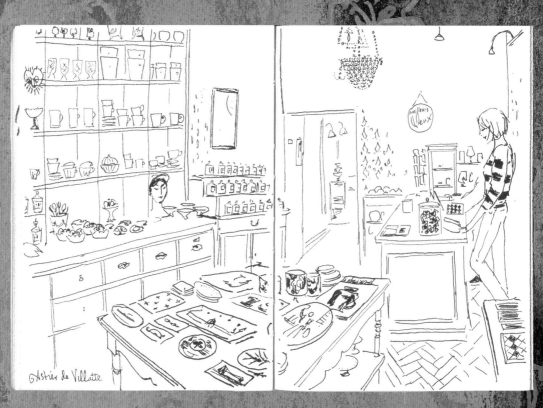

MONTE CARLO

RUE SAINT HONORE

LA TOURNELLE

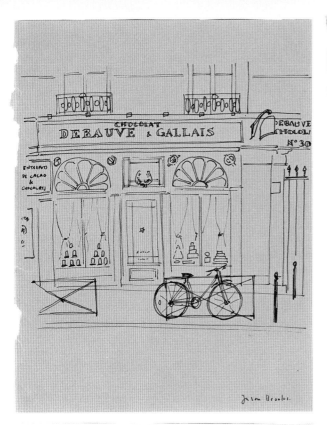

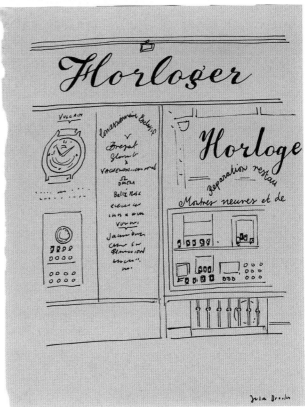

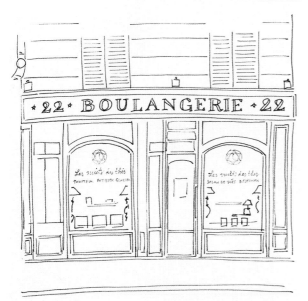

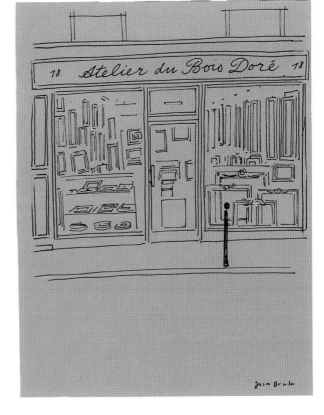

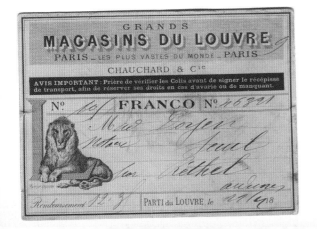

Above: Assorted shop fronts including the chocolatier Debauve Gallais on the Rue Bonaparte.

Left: The Grands Magasins du Louvre was one of Paris's first department stores.

Opposite: Astier de Villatte on the Rue St-Honoré sells beautiful ceramics in its distinctive milky white glaze.

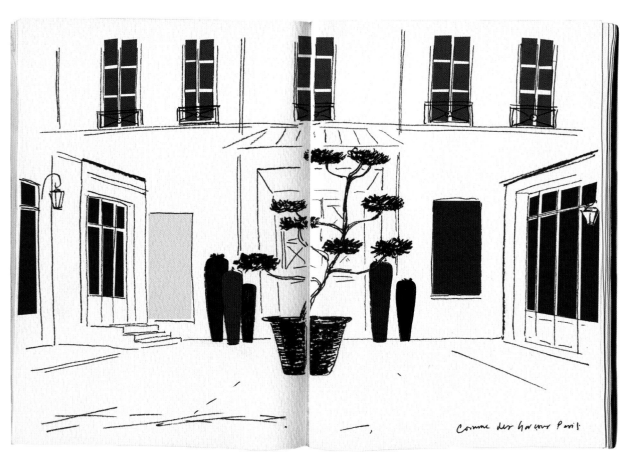

Comme des Garçons. 54 Rue du Faubourg St-Honoré. Two
boutiques face each other across a Zen-like courtyard.

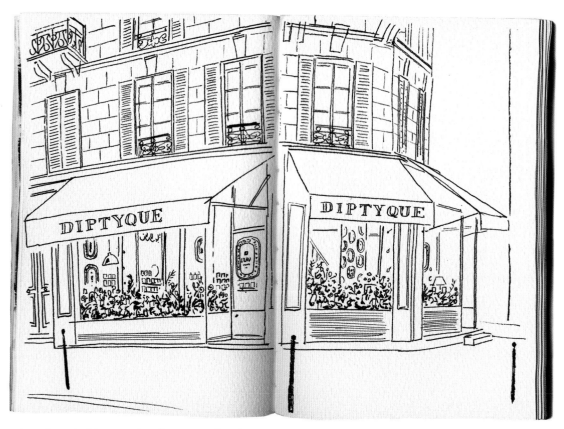

Diptyque. 34 Boulevard St-Germain. Purveyor of the
famous scented candles.

christian Liaigre. 47 Rue du Bac. Very chic high-end
furniture in luxurious materials.

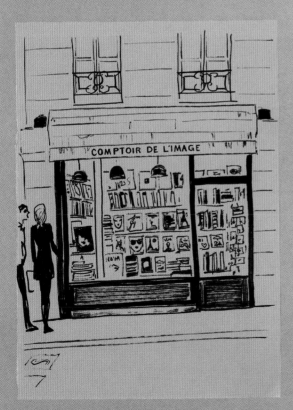

comptoir de l'Image. 44 Rue Sévigné. An
Aladdin's cave of vintage fashion and
photography books and magazines.

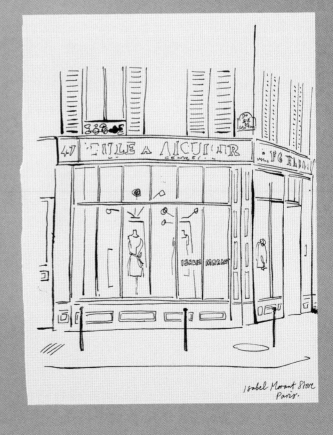

Isabel Marant. 47 Rue Saintonge. clothes that
are the epitome of jet-set bohemian Paris chic.

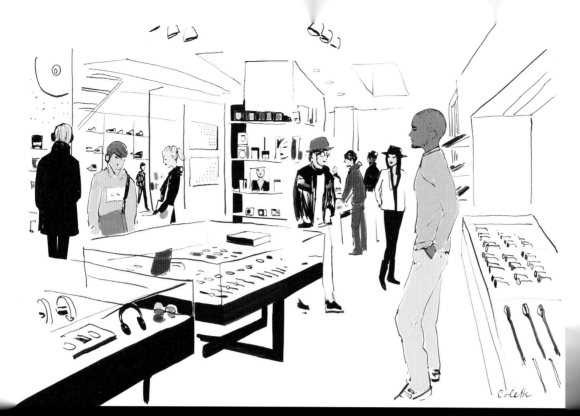

olette, 213 Rue St-Honoré. colette is always full of urban
nipsters browsing, buying and hanging out. and has a water
bar downstairs.

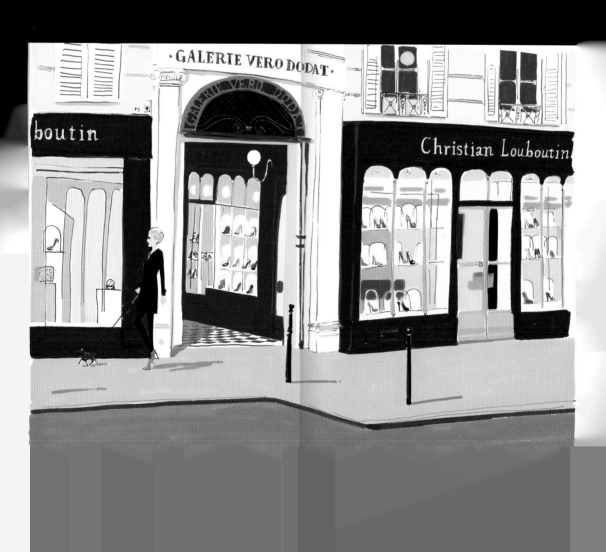

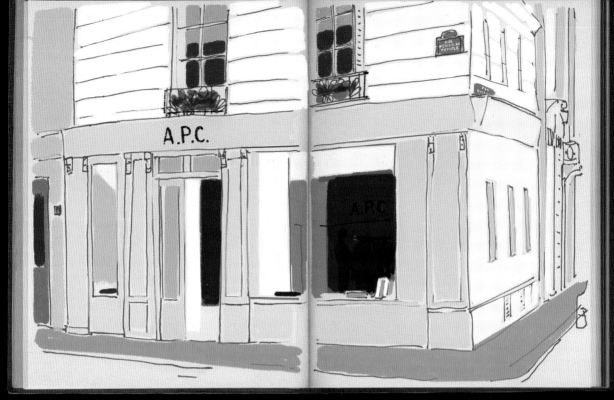

A.P.C., 112 Rue Vieille du Temple. Frequented by Paris's coolest boys and girls and selling very wearable, comfortable and understated clothes.

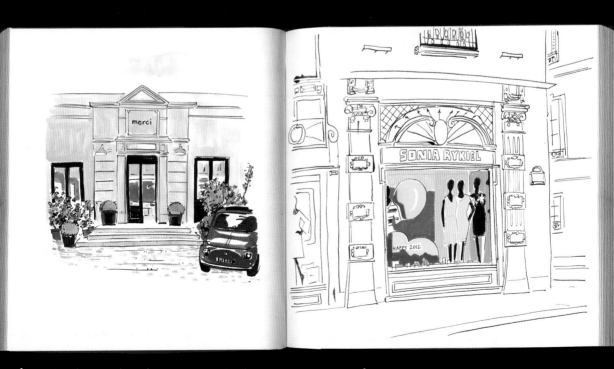

Left: Merci, 111 Boulevard Beaumarchais. A great selection of homeware, fashion, stationery and design labels. It also has a flower stall and café.

Right: Sonia Rykiel, 175 Boulevard St-Germain. A legend of

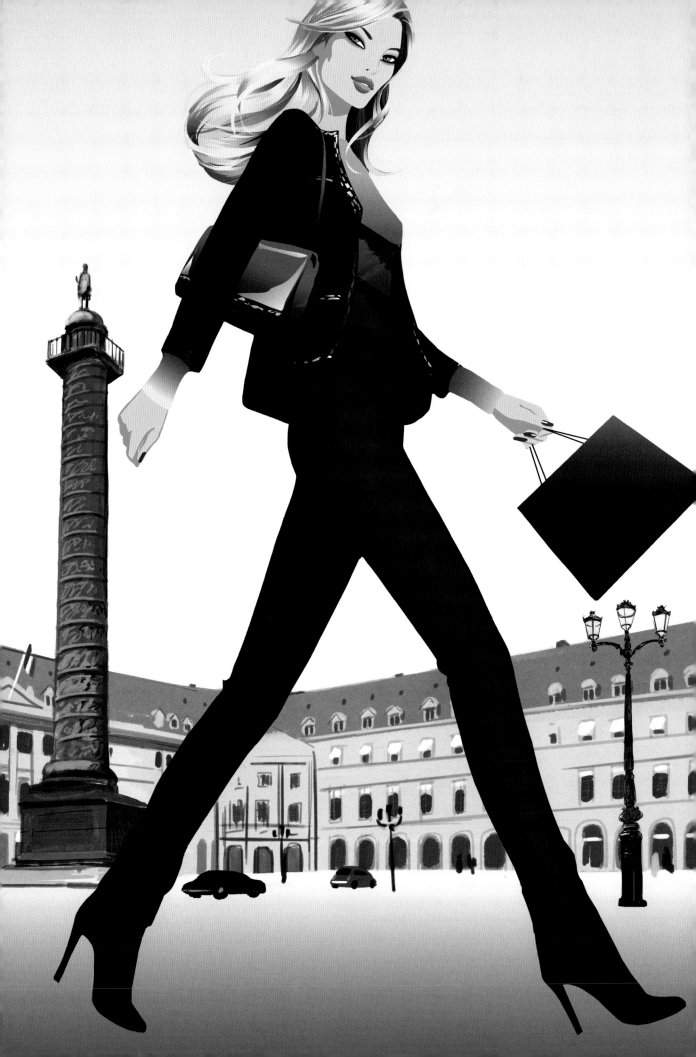

'I have two Loves, my Country, and Paris'

Josephine Baker

I have two Loves, my Country, and Fannie.

Josephine Baker

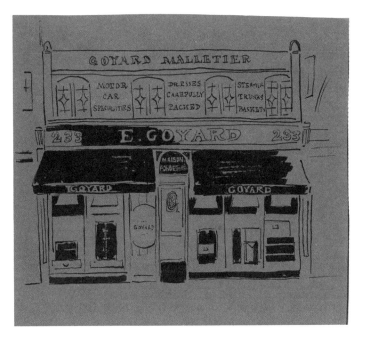

Goyard 233 Rue St Honore
P·A·R·I·S

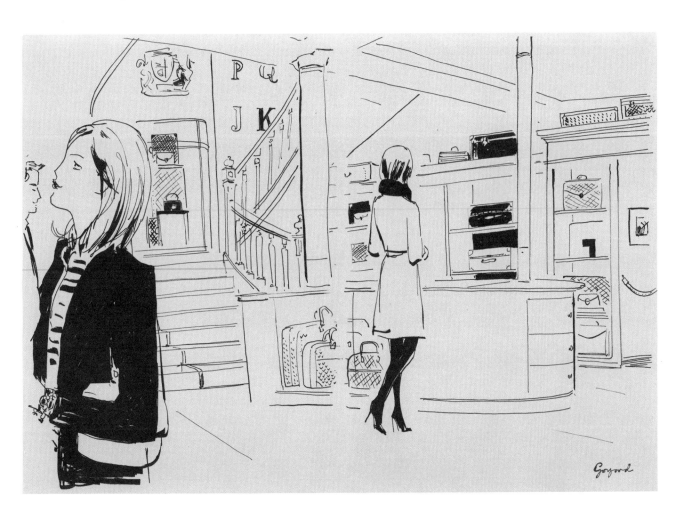

Above: Goyard, 233 and 352 Rue St-Honoré, make gorgeous cases, trunks and accessories, often featuring their signature geometric print.

Opposite: Woman shopping in the spectacular Place Vendôme.

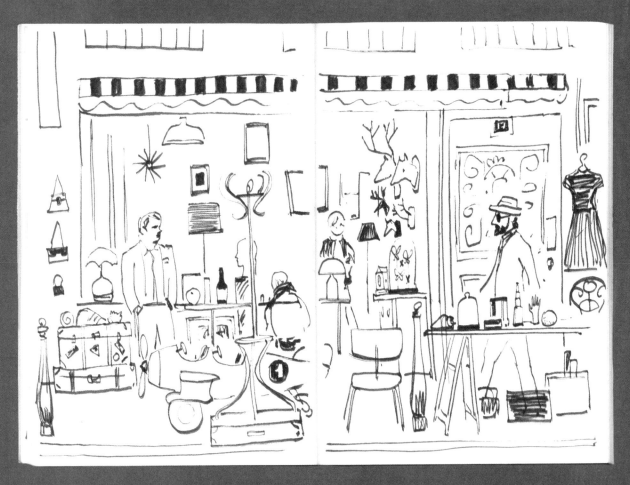

PARIS
CAPITALE DE L'ANTIQUAIRE

Above and opposite: Drawings from the markets at Porte de clignancourt.
and the Marché des Enfants Rouges. Street markets play a big part in
Parisian life.

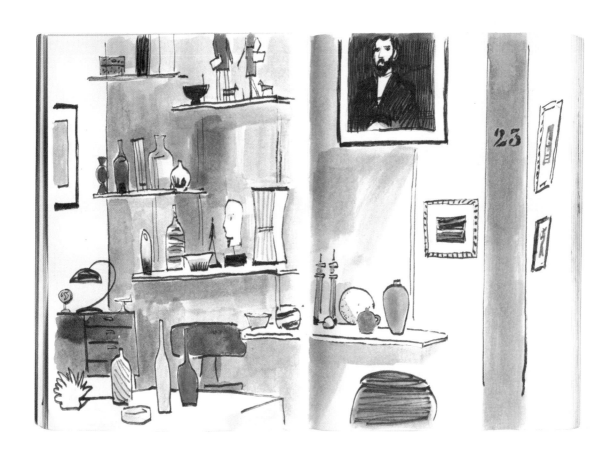

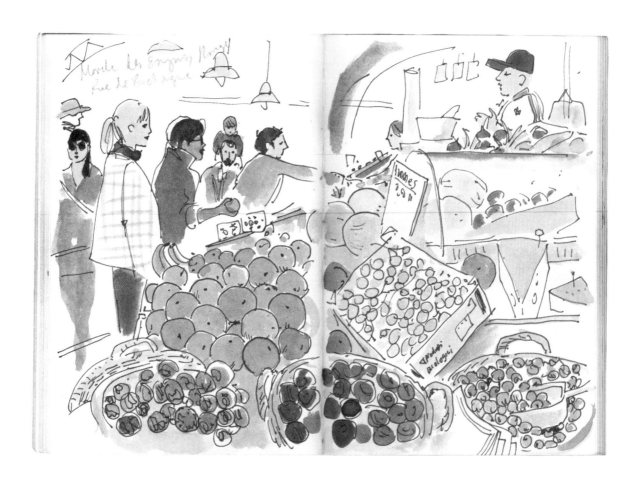

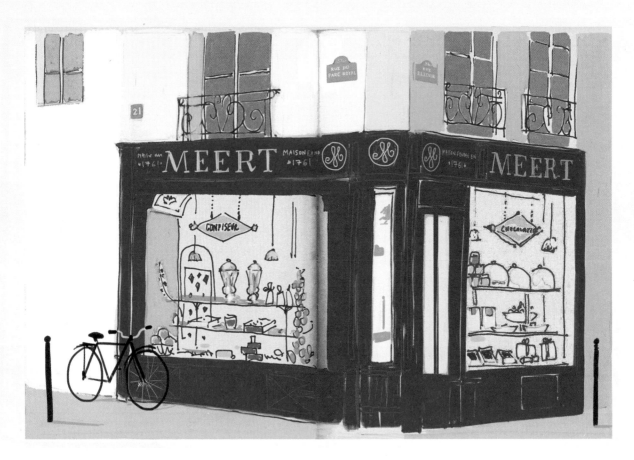

Above: Meert, 16 Rue Elzévir, a charming confiserie-patisserie.

Below: Deyrolle, 46 Rue du Bac is like a compact natural history museum.

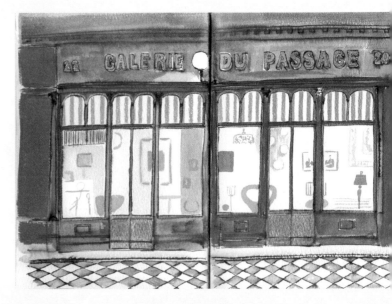

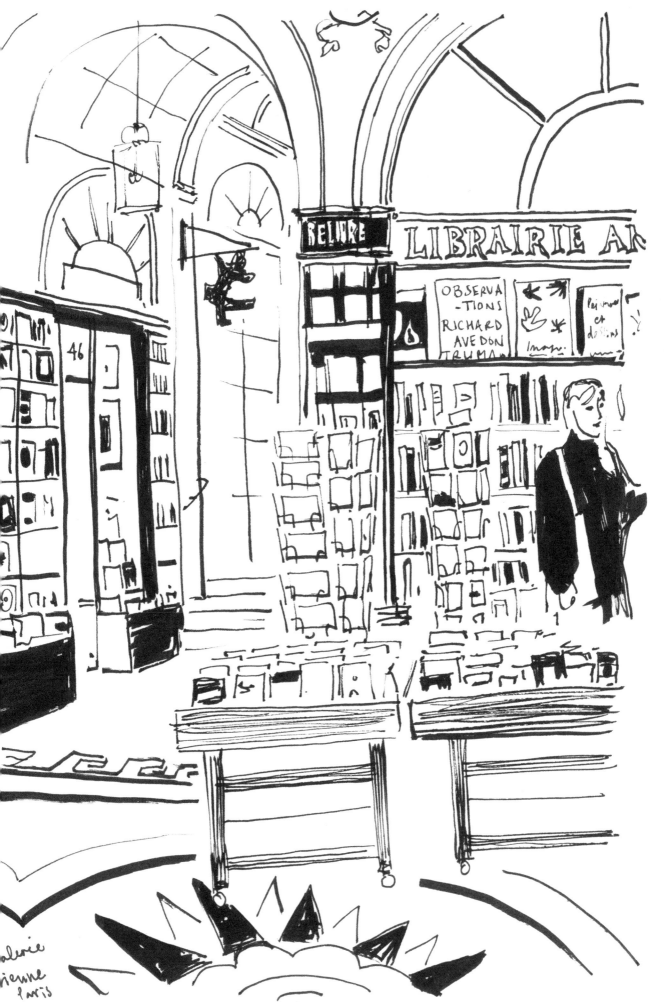

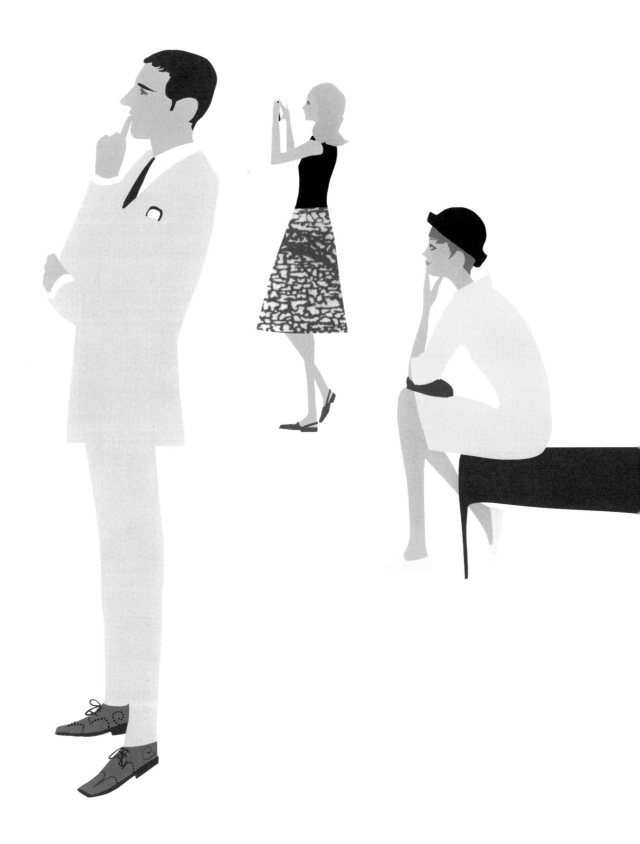

Art

Paris has long attracted artists to live, study and find inspiration, from Picasso to Monet, Toulouse-Lautrec to Hockney. It is also home to some of the finest and most important art collections in the world. The Louvre alone houses tens of thousands of art treasures, spanning centuries in its cavernous galleries, wings and vaults including such masterpieces as the *Mona Lisa*, the *Virgin of the Rocks* and the *Venus de Milo*.

The Musée d'Orsay, Centre Pompidou and Musée d'Art Moderne are host to spectacular collections from more recent art history, and there are a wealth of fascinating galleries, museums and former artists' residences to explore including the Musée Rodin, Musée de l'Orangerie, Fondation Cartier, Musée de Cluny and Musée du Quai Branly to name but a few.

If I had only one day in Paris I would head for the Musée Picasso. It contains a spectacular collection of over 3,000 of his works, a small fraction of what he produced in his lifetime, housed in a beautiful old hôtel particulier in the Marais.

The fortunes of Paris as a cutting-edge centre for innovation and great leaps forward in art and literature have fluctuated over the centuries, but with each successive wave of discovery and exploration, masterpieces in every field of the visual arts have been created here.

LOUVRE
PYRAMID

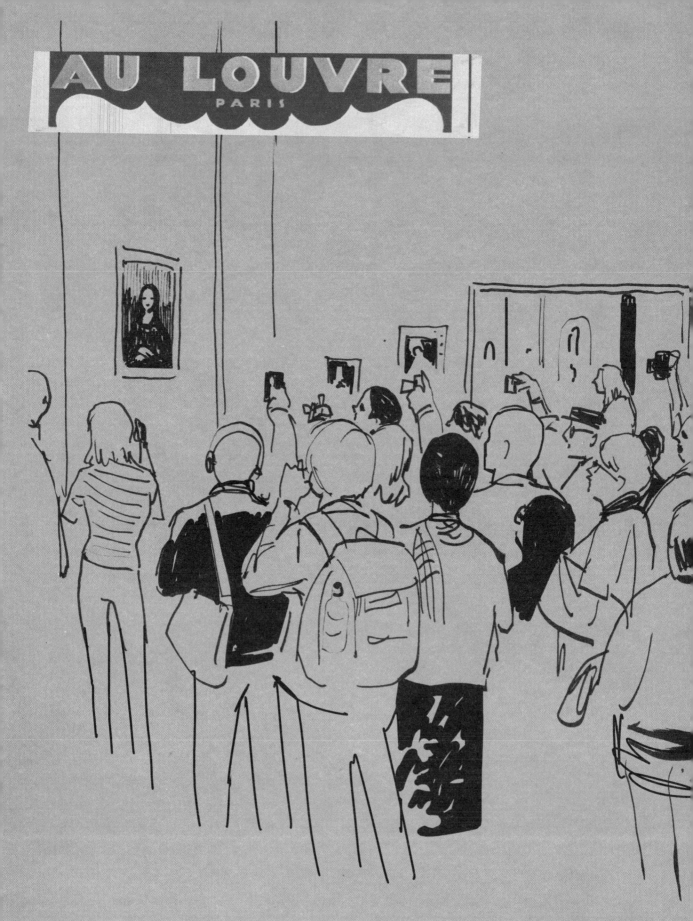

An audience with the Mona Lisa, centuries ahead of its time. Leonardo's masterpiece still has a magnetic power to fascinate like no other painting. Her gaze is seductive, her eyes and mouth smile in a way that is both fondly amused and knowing, making the viewer feel regarded in return.

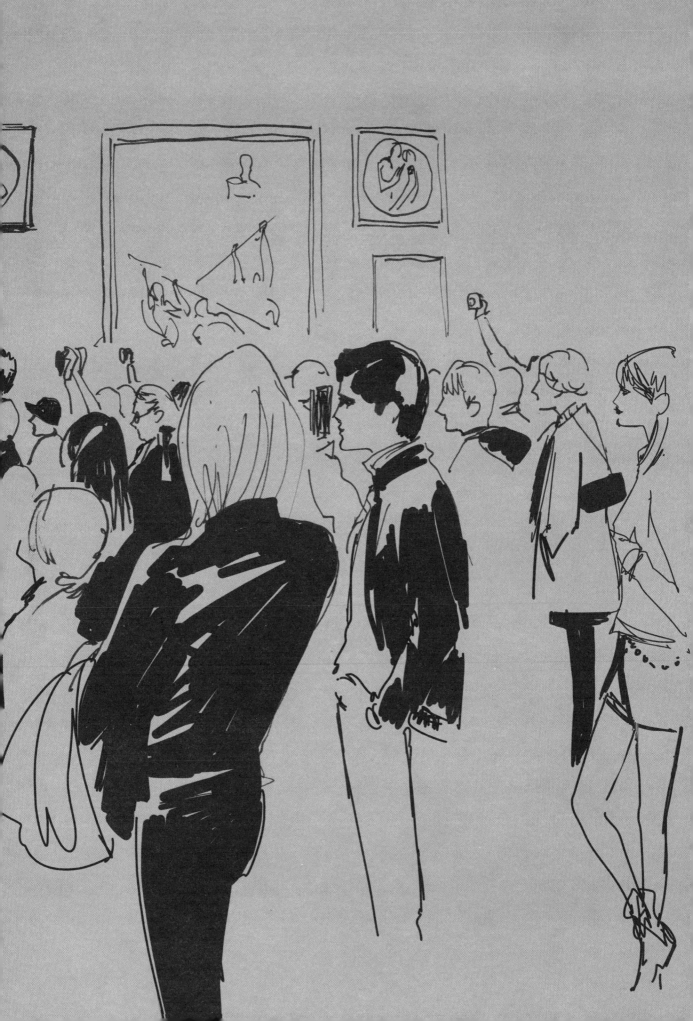

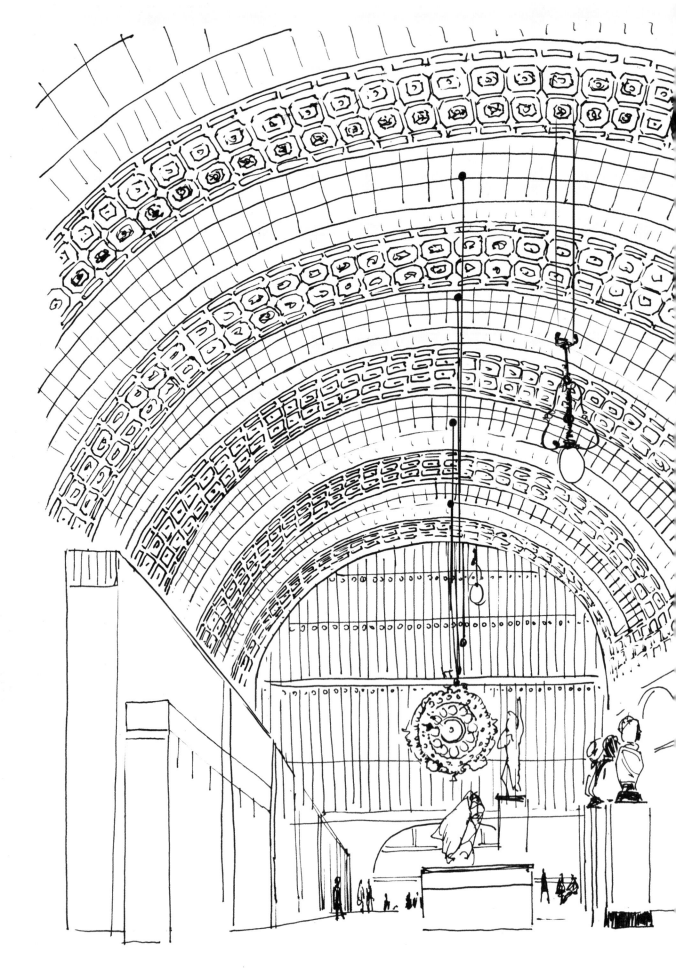

This is the main hall of the wonderful Musée d'Orsay. It's Thursday late night opening, very quiet and impossible not to feel a thrill of excitement at being here.

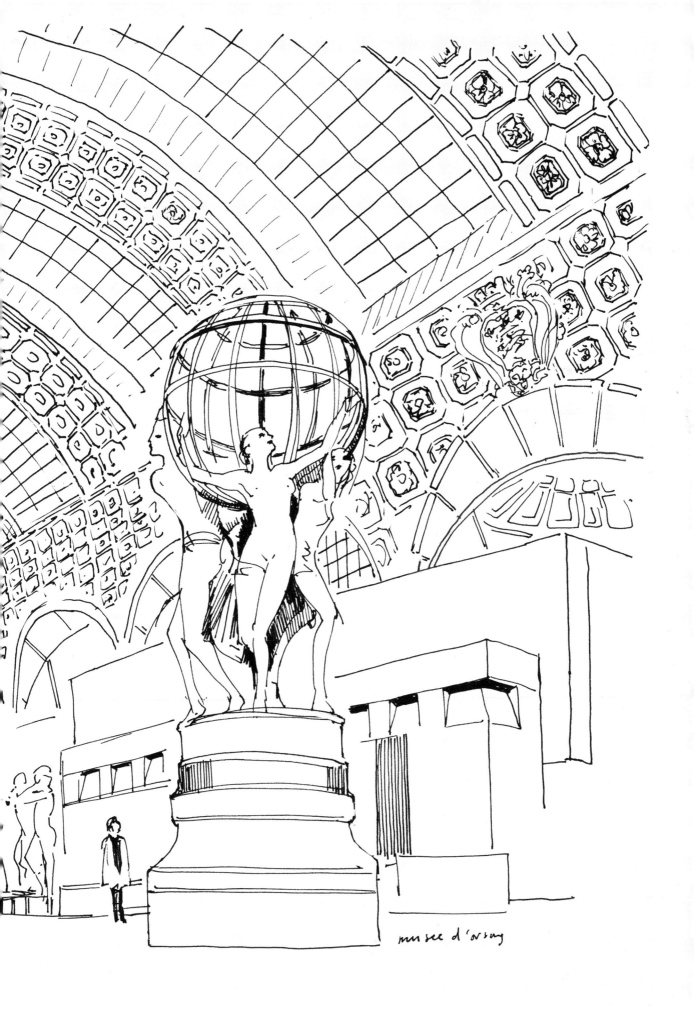

musée d'orsay

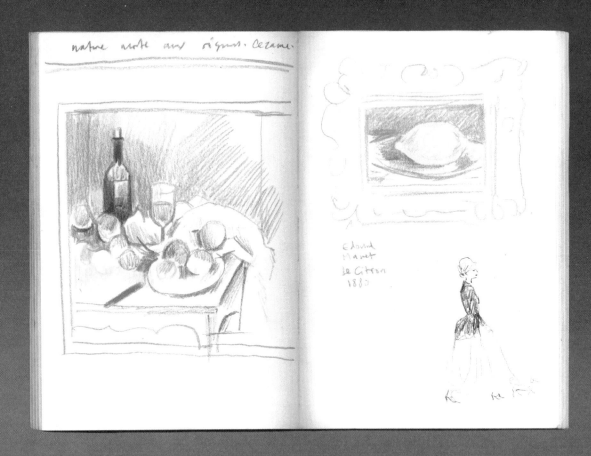

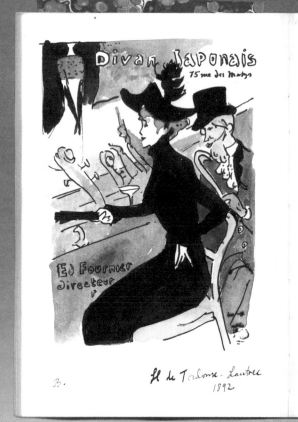

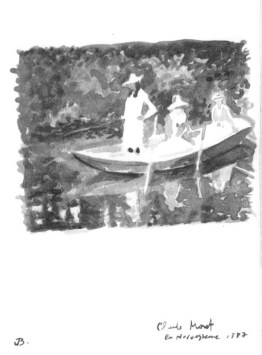

Top left: Paul Cézanne, *Nature Morte aux Oignons*, 1896–98
Top right: Édouard Manet, *Le Citron*, 1880
Bottom left: Henri de Toulouse-Lautrec, *Divan Japonais*, 1892
Bottom right: Claude Monet, *En Norvégienne*, c.1887

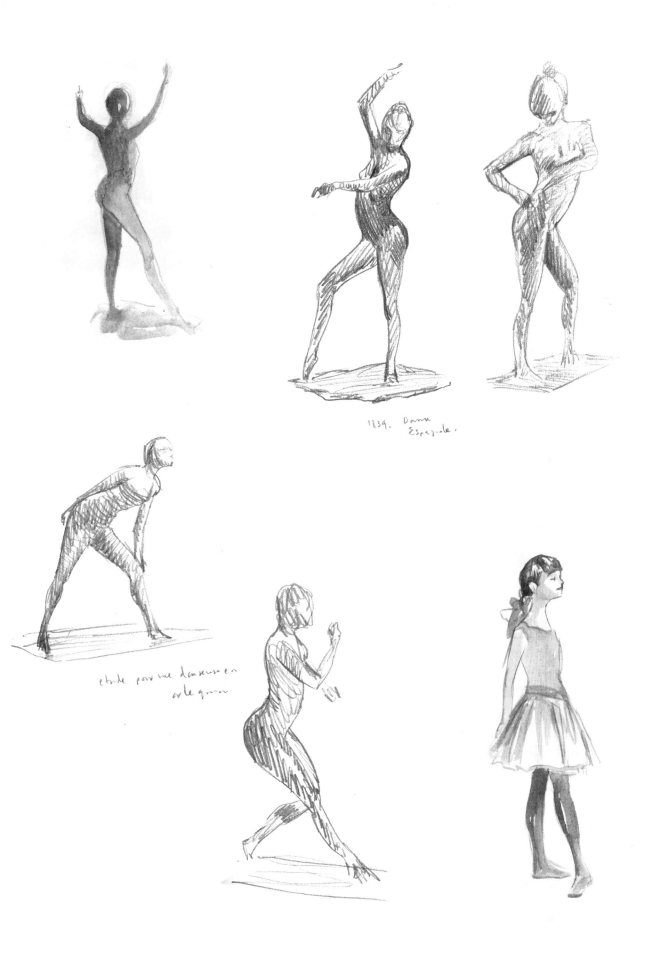

1834. Danse
Espagnole.

etude pour une danseuse en
arlequin

Degas' sculptures are little masterpieces of drawing
in three-dimensional space.

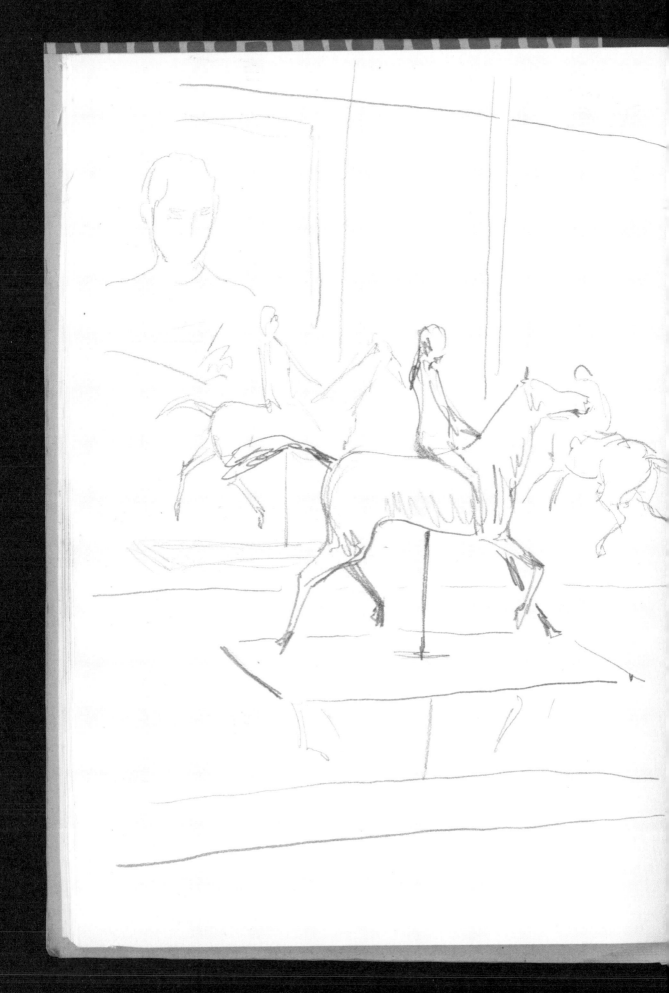

Degas horse bronzes in a mirrored cabinet at the Musée D'Orsay

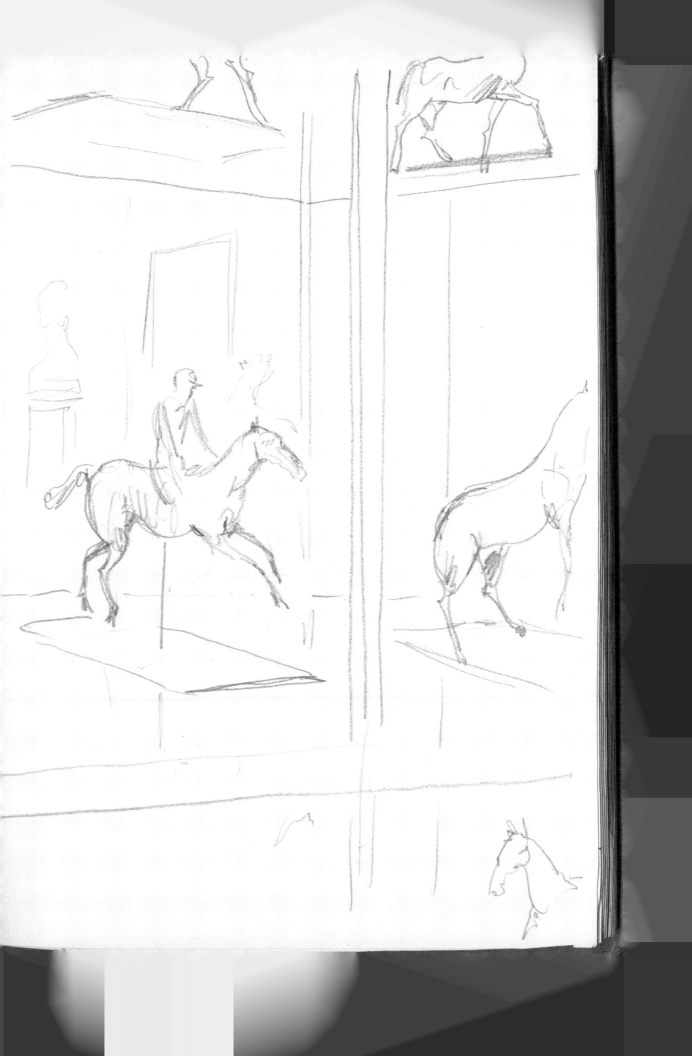

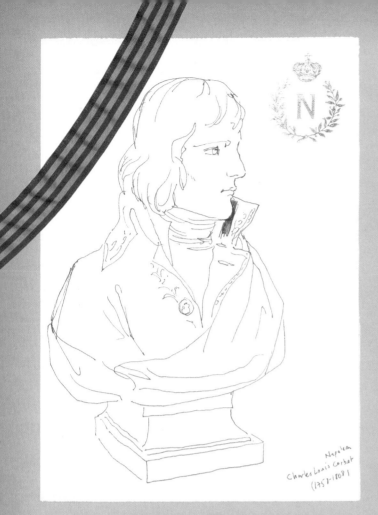

Napoléon
Charles Louis Corbet
(1757-1808)

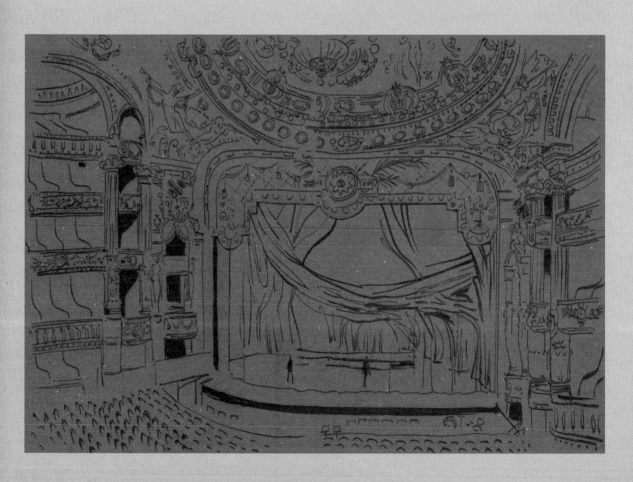

A ceiling mural by Raoul Dufy floats above the auditorium of the Opéra.

Picture frames are a very Parisian obsession.

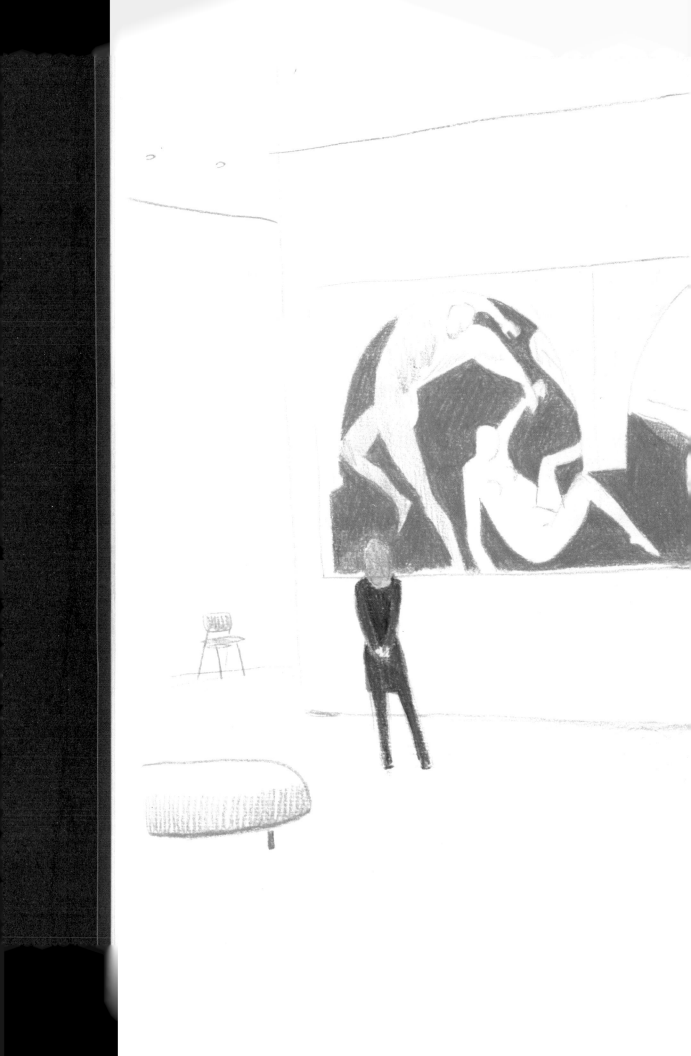

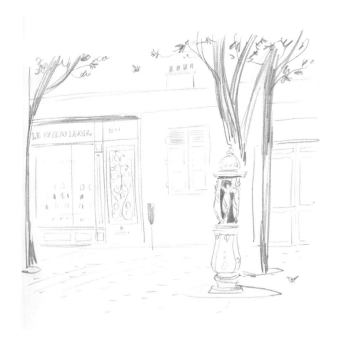

Top: The 'Bateau Lavoir' in the Place Émile Goudeau was once the studio and meeting place of Picasso, Modigliani, Braque, Gris, Morisot and many other artists, writers and intellectuals at the turn of the last century.

Above: These doodles are little figments of my imagination showing imaginary Parisian artists' studios.

Opposite: Still life playing with the position of different Parisian objects.

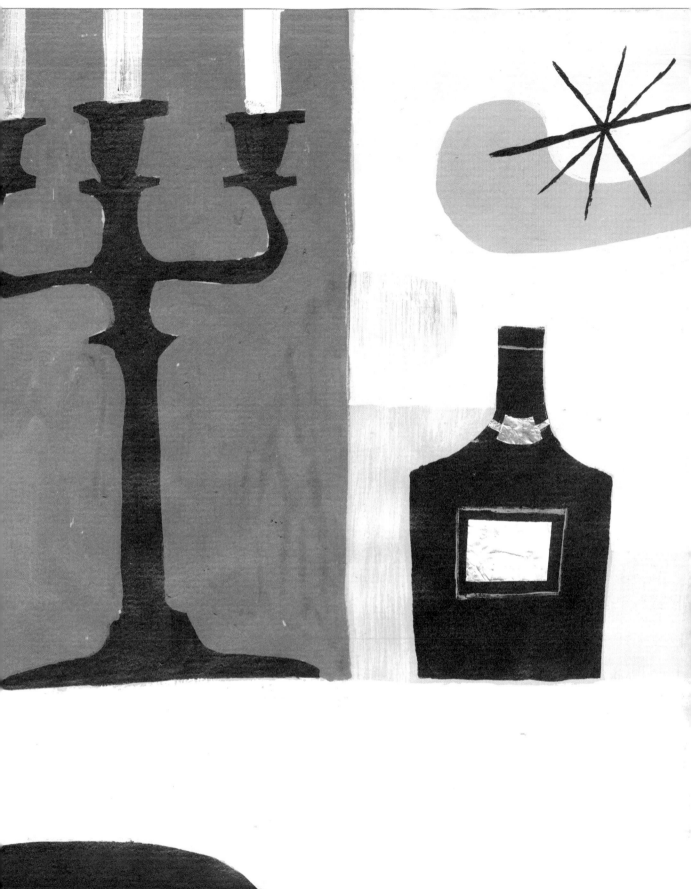

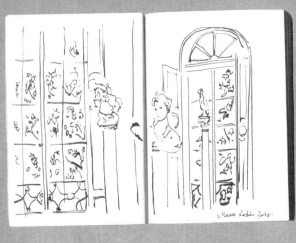

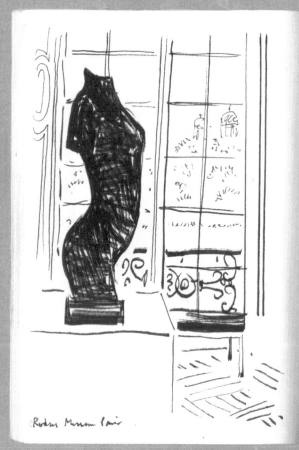

The Musée Rodin housed at the Hotel Biron is like a green oasis
in the heart of Paris. The gardens provide the perfect setting
to contemplate the sensual works of monsieur Rodin.

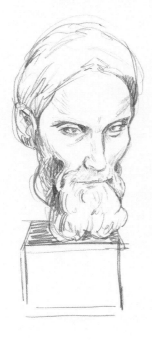

Rodin
Eustache de
Saint-Pierre.
1885-86

Rodin
1870

Rodin's
Danaïd
1889-90

Musée du Quai Branly

The Musée du Quai Branly. Opened in 2006.
this relatively new museum designed by Jean
Nouvel contains an amazing collection of
ethnographic objects. A vertical garden to one
side of the main building often attracts a
crowd of astonished onlookers. and the museum
itself is beautifully designed and lit.

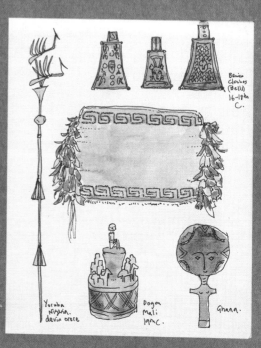

Modigliani's Femme aux Yeux d'un Bleu Transparent at the Musée d'Art Moderne.

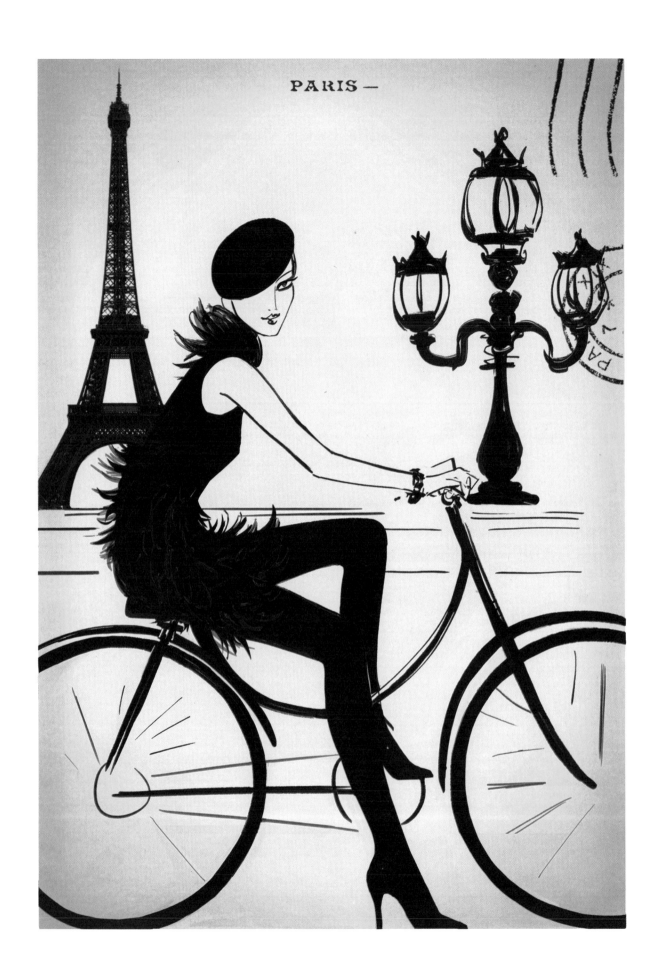

PARIS —

A to B

Millions of journeys a day provide the life force of any city. Perhaps the most pleasing way of getting around Paris is on foot, as a 'flâneur', a term popularised by the poet Charles Baudelaire. Flâneurs are those who stroll the streets and boulevards, perhaps in search of inspiration, or simply to enjoy the sensory delights of the city.

For people in more of a hurry, two wheels are often the fastest means of getting from A to B, and bikes of all kinds proliferate and compete in a seemingly never-ending race with taxis, limousines, trucks, cars and three-wheelers.

Naturally, in Paris, a rider's means of transport is also a vehicle for expressing his or her personal style. Perfectly colour-coordinated vintage Vespas show finely tuned aesthetic sensibilities while an elegant '70s Mercedes convertible or Citroën might speak of understated style and status. Parisians have also embraced public bike hire, and the neat mushroom grey 'Vélib' – Vé for vélo (bicycle) and lib for liberté (freedom) – have become a feature of the city's streets and a democratic style statement of their own.

The Seine provides the city's main thoroughfare and a wide grey-green highway for all kinds of river traffic, while above all, or should I say beneath all, Paris has its glorious Metro.

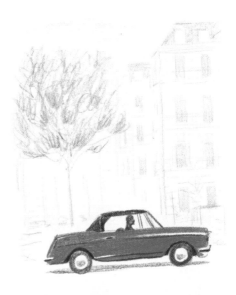

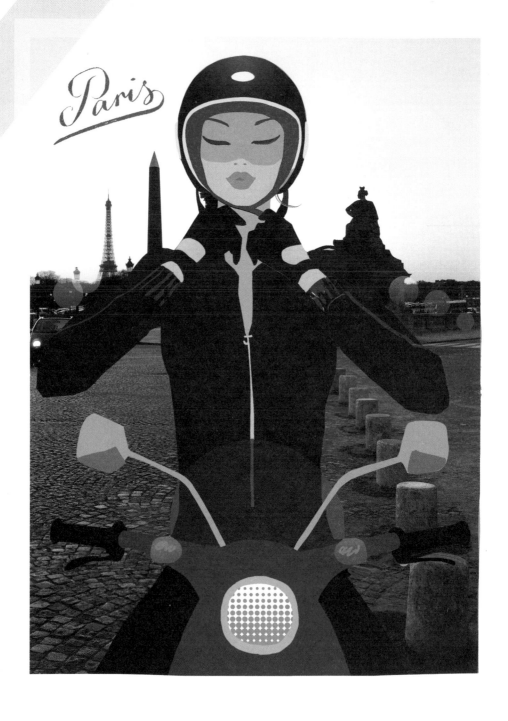

Above: The buzz of scooters can be heard everywhere in Paris and they are one of the most efficient means of getting from A to B.

Opposite: This picture was inspired by a very atmospheric driving scene in Jean-Luc Godard's classic French New Wave film *Breathless* shot in a late 1950s Paris summer.

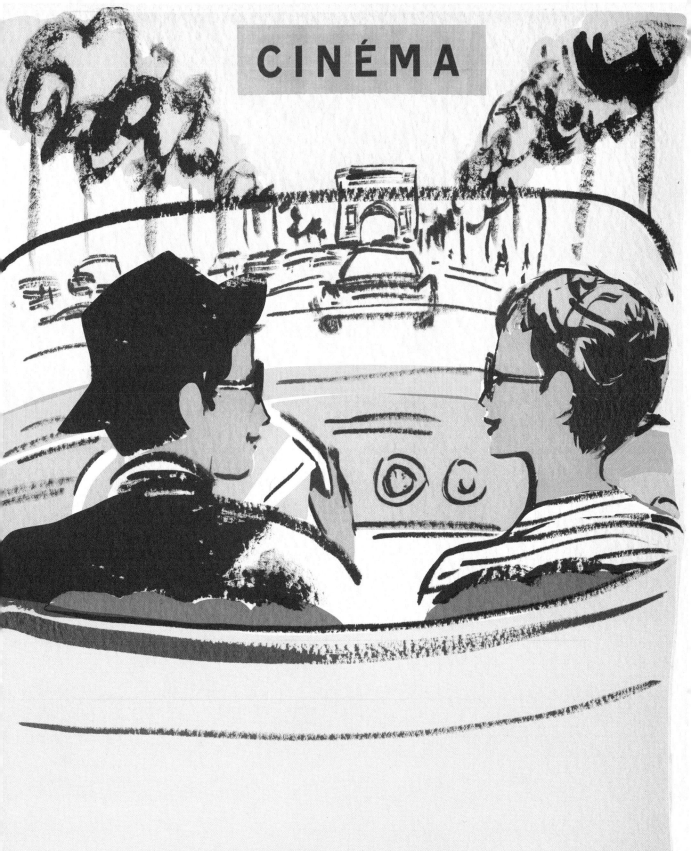

CINÉMA

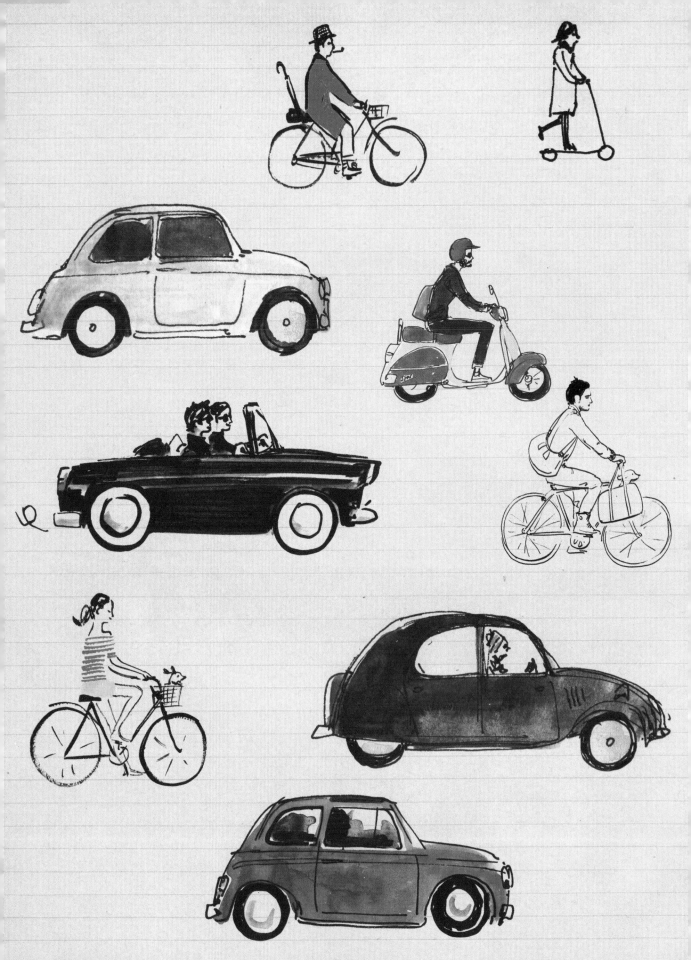

The most fashionable cars in Paris appear to be miniature
city run-arounds. like the black Autobianchi convertible above,
and little Fiat 500s.

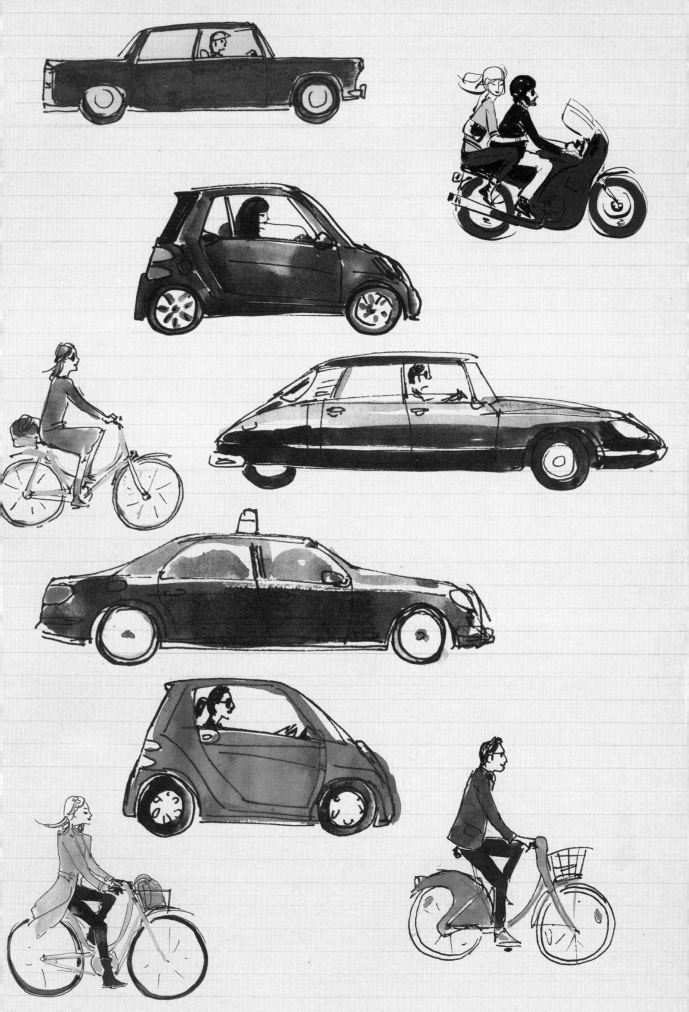

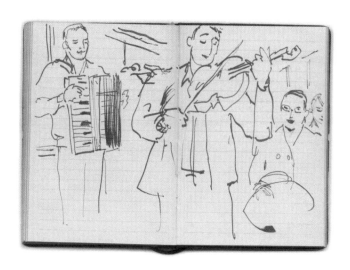

This violinist and accordion player on the Metro played lively folk tunes with a twinkle in their eyes.

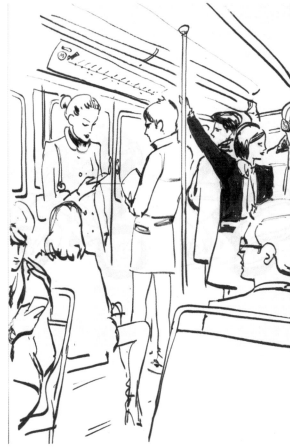

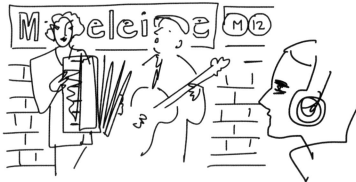

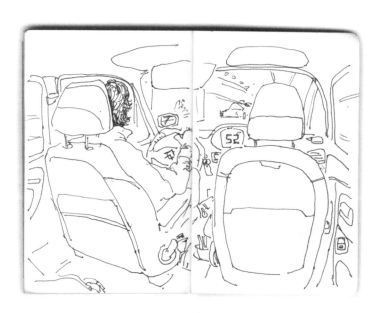

In the back of a taxi soon to navigate the Place de la Concorde.

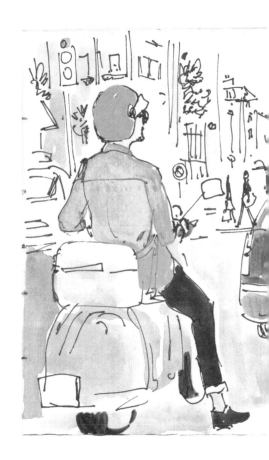

This guy looked very cool in a trench coat and Ateliers Ruby crash helmet.

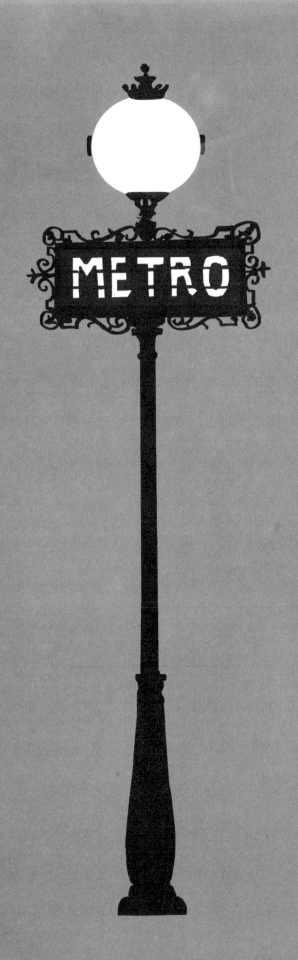

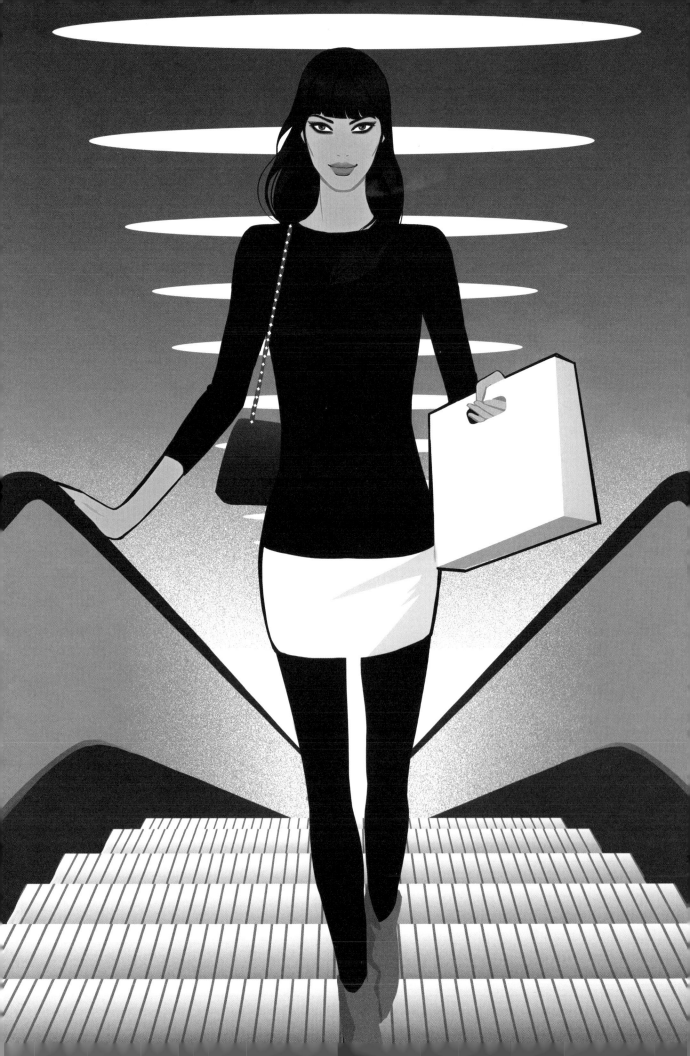

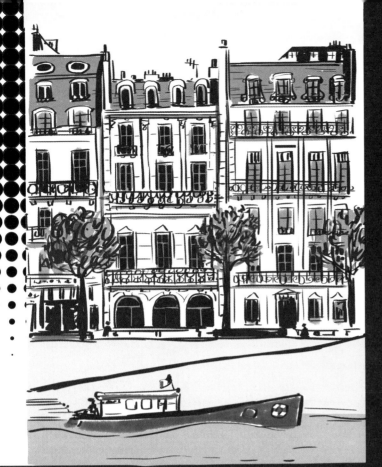

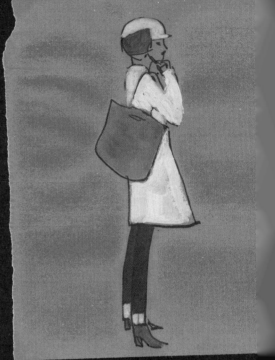

Above: River traffic near the Pont Neuf.

Right: Assorted street scenes.

Opposite: This picture is based on how the Auber Metro Station looked in the early 1970s.

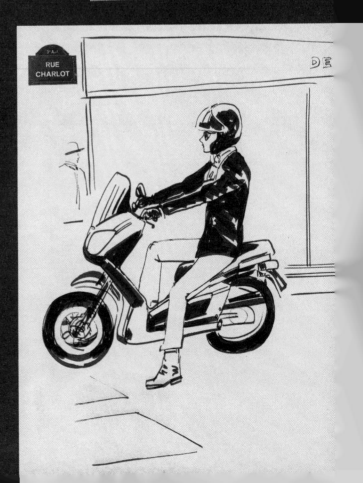

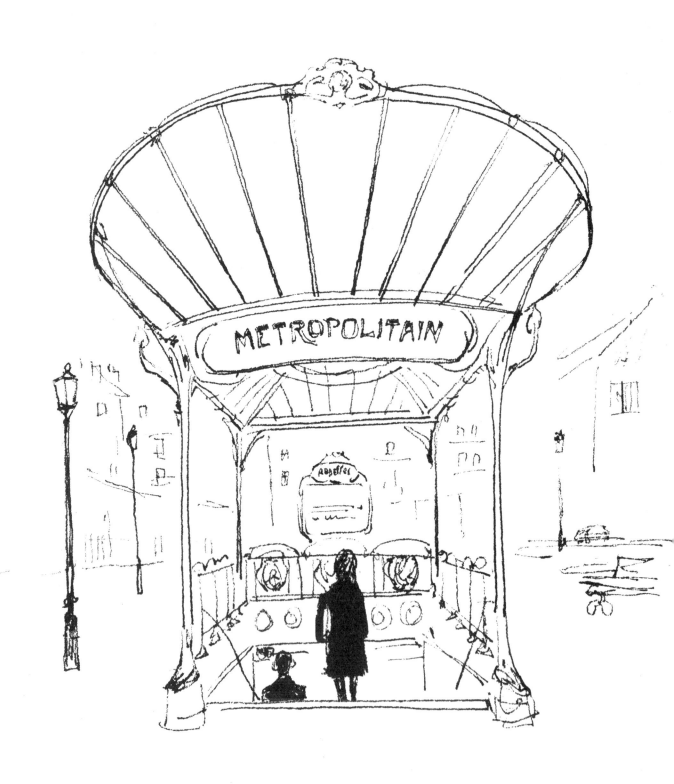

Above: Hector Grimaud's wonderfully strange and distinctive
Art Nouveau Metro entrances evoke a different age, like elegant
triffids sprouting from the Paris pavements.

Opposite: At the Iéna Metro station, glazed ceramic picture frames
present publicity posters as high art.

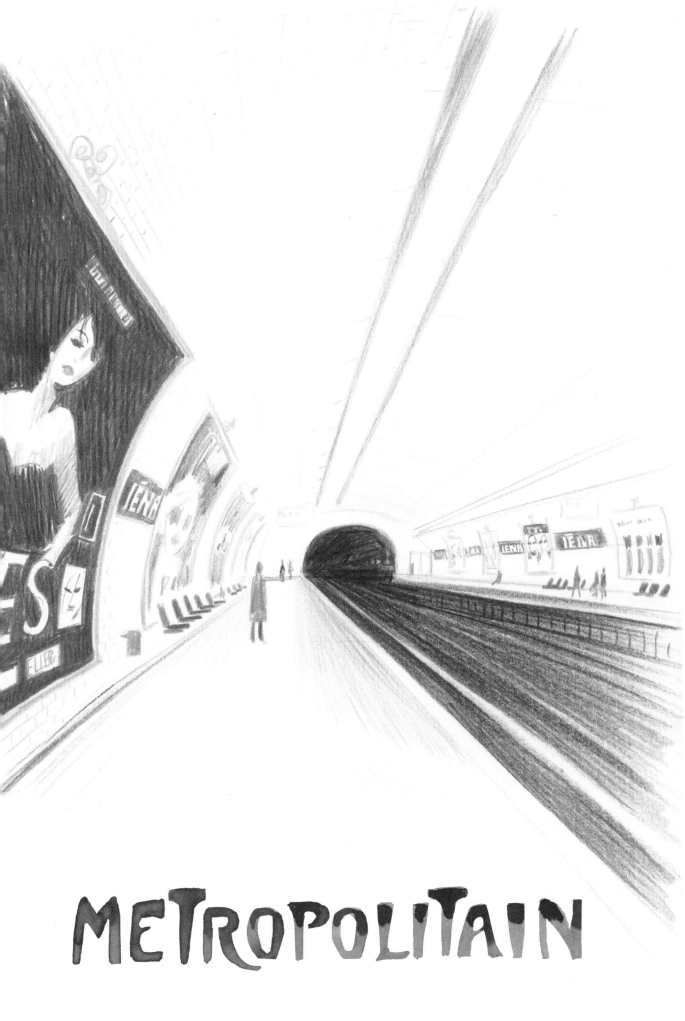

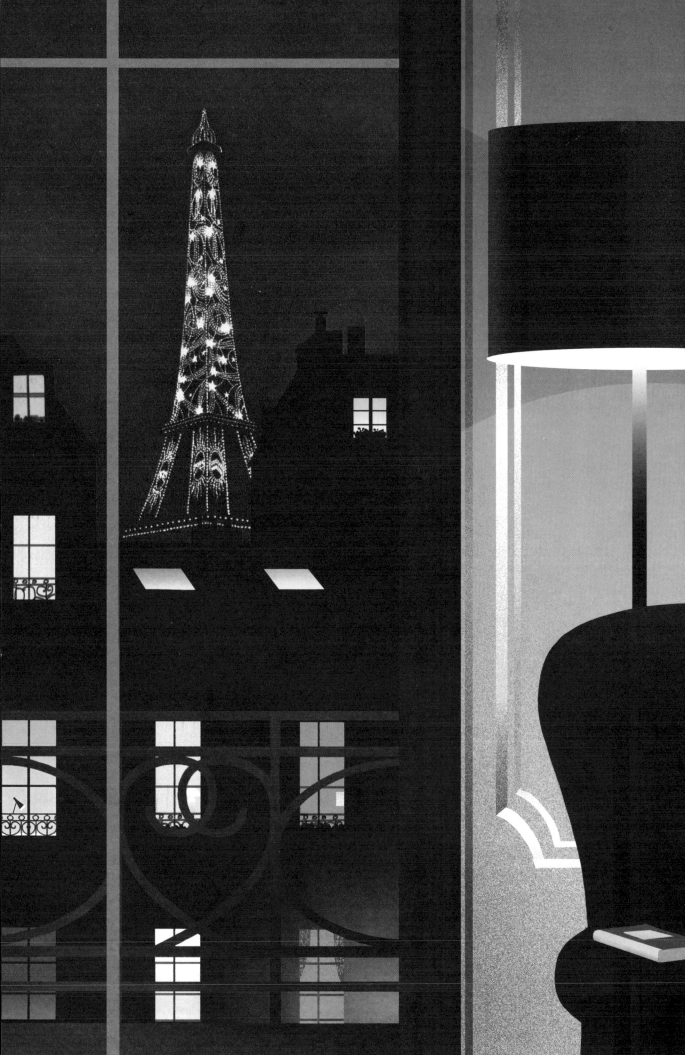

La Nuit

Nightfall is when the City of Light lives up to its name. To the north the Sacré-Coeur is spotlit from below, giving the familiar domes a glamorous Hollywood quality, and from here the city stretches out, a sea of glittering lights. Neon calligraphy overlaps and reflects in absinthe greens, hot oranges, yellows and pinks, so different from the daytime colours of Paris. Street lamps and illuminated Metro signs flicker into life, and car headlights glow warm and yellow like fireflies as they surge forward and slow to the pulse of traffic lights.

Shop windows on the Rue St-Honoré convert to their night-time alter egos, displaying artfully lit silent tableaux. Restaurants, bistros and cafés come alive with throngs of people on every corner and look warmly convivial, cosy and inviting. The great boulevards become processions of standing streetlights that lead the eye away and up to the grand buildings.

Lighted windows provide glimpses into private worlds framed against the dark rooftops and chimney pots. Down by the Seine the bridges and riverfront buildings scatter points of light onto the slopping water that dance and shimmer, occasionally disturbed by the passing of river traffic. The Tuileries gardens become inky, and in the distance the Grande Roue is reflected in fountains like an inverted Catherine wheel. The Louvre pyramid and courtyard become a spectacular film set, the great dark roofs punctuated by skylights that glow mysteriously, and above the entire city the Eiffel Tower glitters at intervals while the beam of its searchlight sweeps the sky.

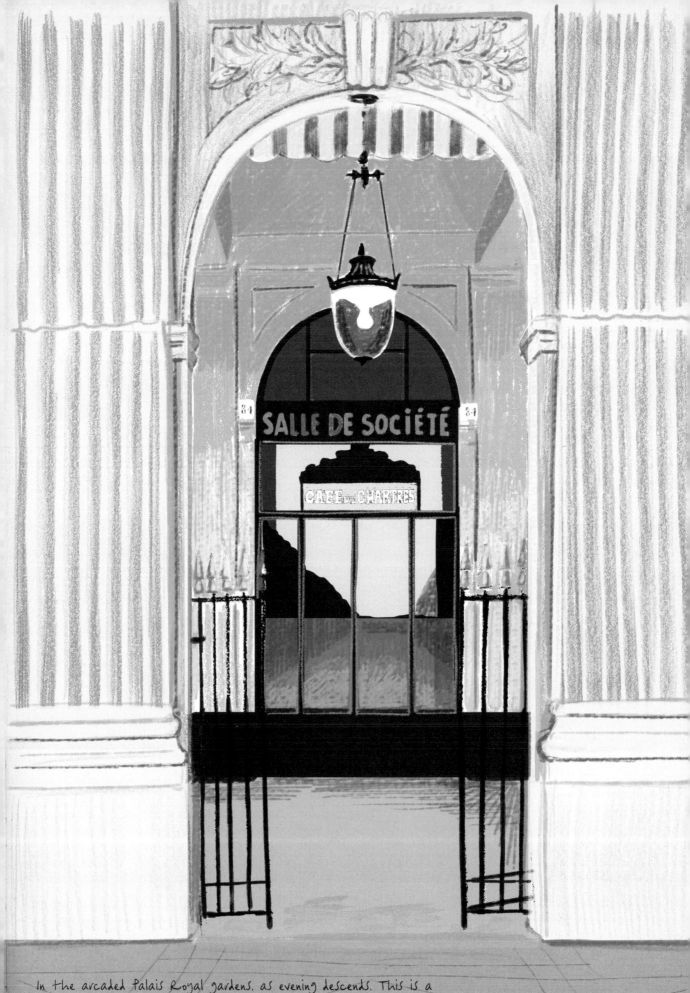

In the arcaded Palais Royal gardens, as evening descends. This is a
magical place to enjoy the transition from daylight to darkness.

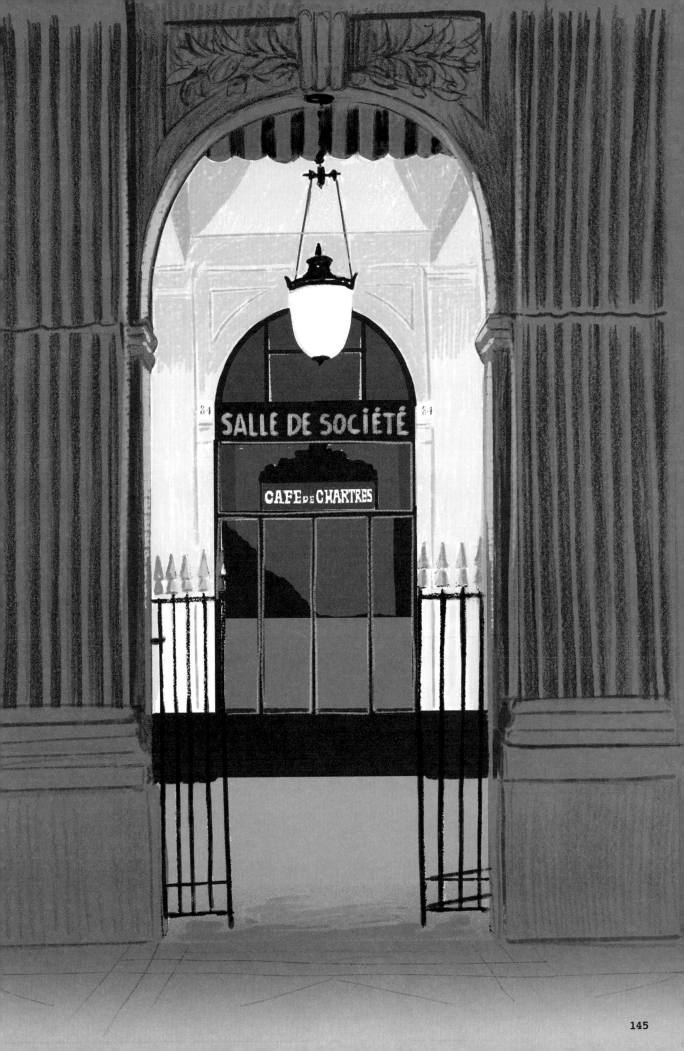

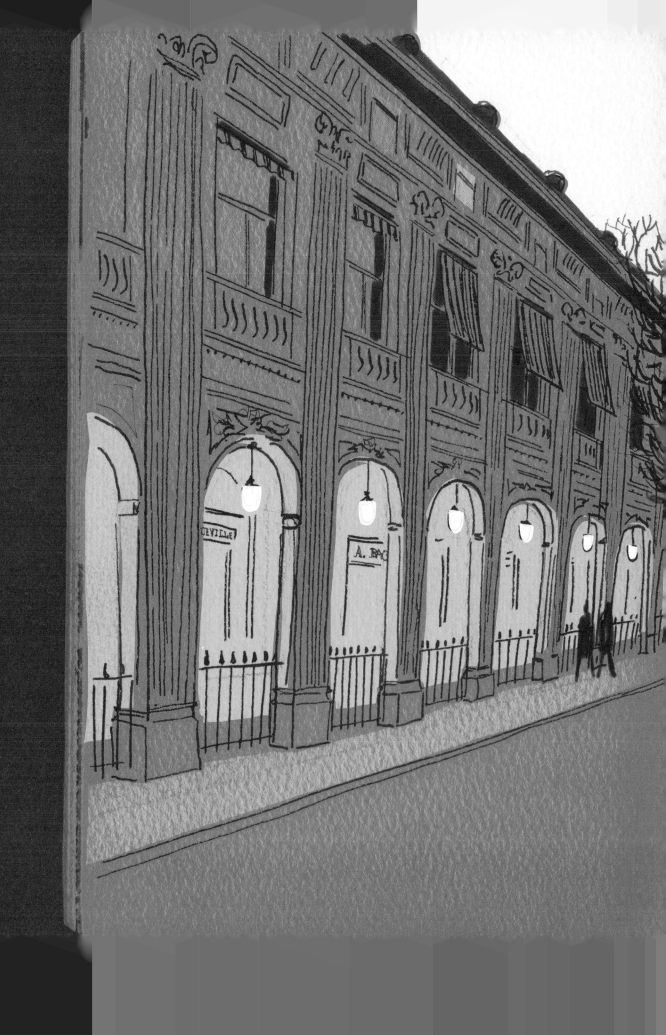

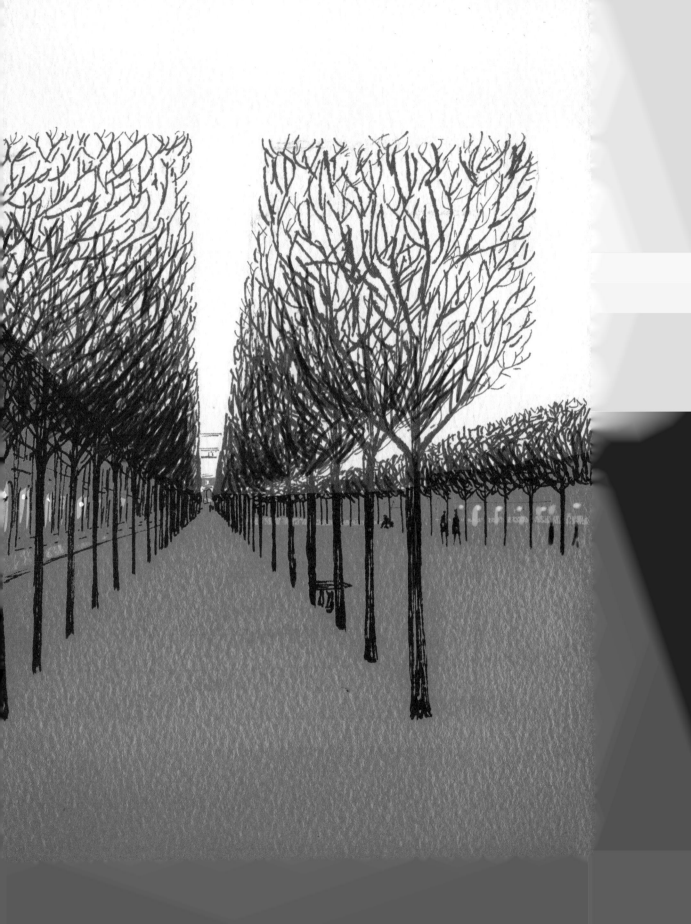

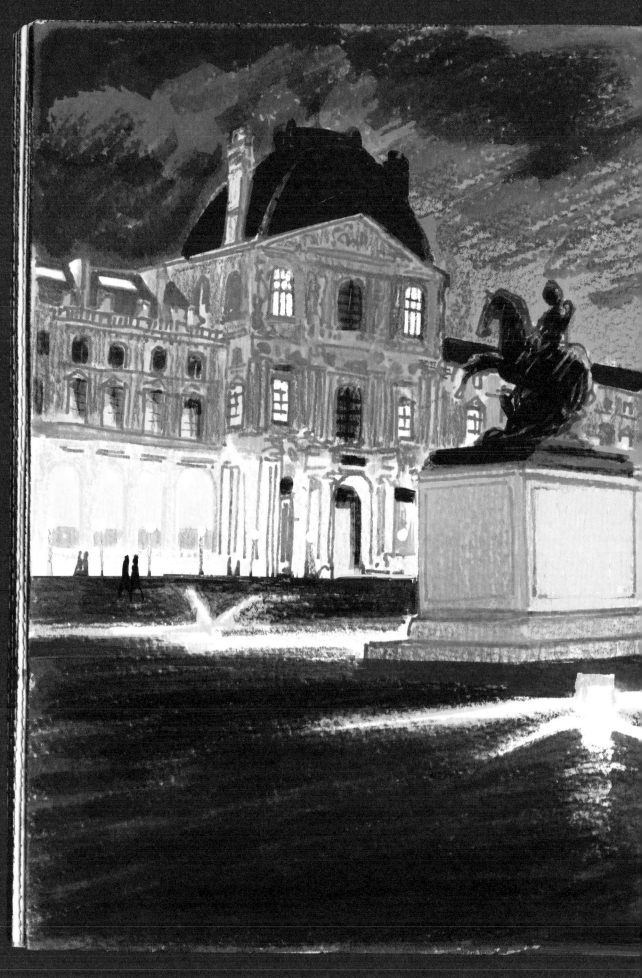

The Musée du Louvre courtyard on a dramatic stormy night.

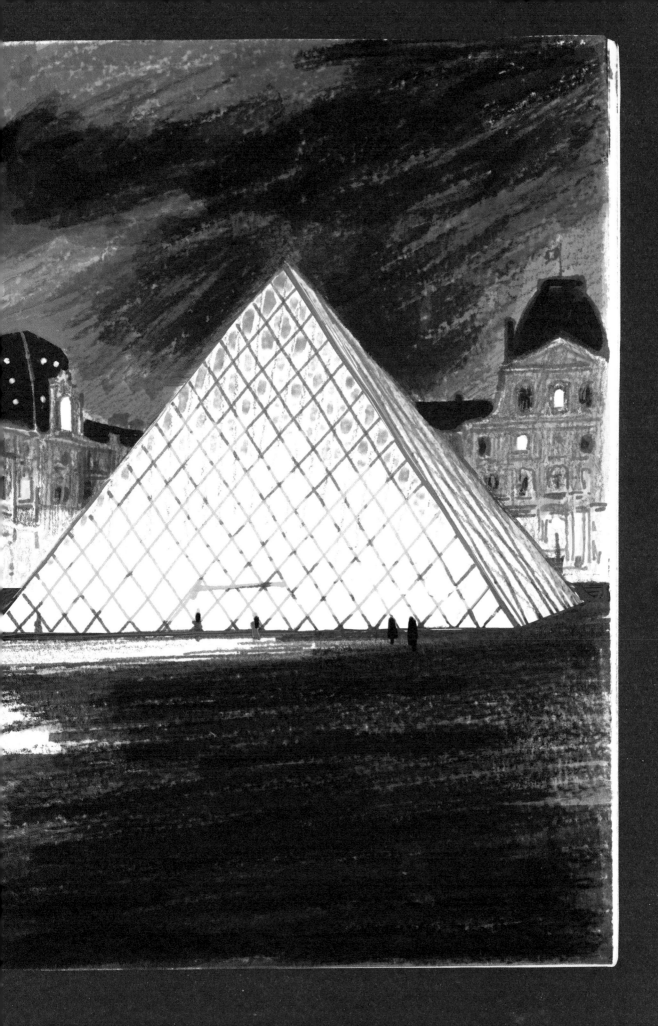

Above and opposite: During the 'Belle Époque' electric lighting arrived in Paris, transforming the night into a dazzling spectacle. People thronged to cabarets, bistros and restaurants including the Moulin Rouge, Folies-Bergère and Maxim's.

Opposite, bottom: Absinthe is forever associated with bohemian Paris, and the 'green fairy' still retains her mystique.

moteur (mo'tœr), a. (fem. **motrice**) Motive, propelling, moving, driving. n.m. Mover, propeller, contriver; motive power, author. (Anat.) motor.

motif (mo'tif), a. (fem. **motive**) Moving, causing, inciting. n.m. Motive, incentive, ground, cause; (Mus. etc.) motif, theme, design. Faire valoir les motifs, (Law) to show cause; pour quel motif? on what ground?

motion (mo'sjɔ̃), n.f. Motion. Faire, appuyer, ou faire adopter une motion, to make, to support, or to carry a motion.

motiver (moti've), v.t. To allege as a motive; to be the motive or cause of, to bring about, to justify.

motocyclette (motosi'klɛt), n.f. Motor-cycle.

motrice [MOTEUR].

motte (mot), n.f. Clod; bank of earth; mound. Motte à brûler, peat, turf; motte de gazon, sod of turf.

motter, v.t. To throw clods at (sheep etc.).

motter, v.r. (Hunt.) To hide behind a clod.

motteux (mo'tø), n.m. Wheatear.

motus! (mo'tyːs), int. (colloq.) Mum! silence! not a word!

mou (mu), a. (mol before vowel or h mute, fem. **molle**) Soft; mellow; weak, feeble; slack, flabby; sluggish, indolent; tame, effeminate; careless, luxurious. Cire molle, soft wax; eau molle, slack water; poires molles, mellow pears; style mou, nerveless style. n.m. Soft part or thing; slack (of a rope); lights (esp. of calves).

mouchage (mu'ʃaːʒ), n.m. Snuffing (of candles).

mouchard (mu'ʃaːr), n.m. Police-spy, informer, spy. **moucharder**, v.t. and i. To inform, to spy.

mouche (muʃ), n.f. Fly; speck, spot; patch (on the face), beauty-spot; short imperial (beard); button (of foil); blister-fly; bull's-eye (of a target); river passenger-steamer; (Nav.) advice-boat; (fig.) spy; parasite, pickpocket; unfortunate person; impatience, anger; loo (game of cards). C'est une fine mouche, he or she is a sly dog; chiures ou taches de mouches, blows; des pieds de mouches, scrawl (writing); écrire des pieds de mouches, to write an illegible scrawl; fine mouche, to hit the bull's-eye; gober des mouches, to stand gaping; mouche abeille, drone; mouche à feu, fire-fly; mouche à miel, honey-bee, (fig.) candidate of the Ecole Centrale, Paris; mouche à viande, blow-fly; mouche bleue, blue-bottle; mouche-guêpe, wasp; mouches guêpes, wasp-fly; mouches volantes, motes in the eyes; on prend plus de mouches avec du miel qu'avec du vinaigre, more is done by kindness than by harshness; prendre la mouche, to be touchy; quelle mouche vous a piqué? what's the matter with you? what whim has got into your head?

moucher (mu'ʃe), v.t. To wipe or blow the nose of; to snuff; to spy, to dog; (slang) to reprimand, to wipe down. Moucher une chandelle, to snuff candle; mouchez cet enfant, wipe that child's nose. v.t. To blow one's nose; to zigzag about like a fly. se **moucher**, v.r. To blow one's nose. Moucher, to blow your nose; ne pas se moucher du pied, to be up to snuff, to do things in grand style.

moucherolle (mu'ʃrɔl), n.f. Fly-catcher (bird).

moucheron, n.m. Gnat, midge, very small fly; (slang) youngster, urchin; snuff (of a candle).

mouchet (mu'ʃɛ), n.m. Hedge-warbler.

moucheté (mu'ʃte), a. (fem. **mouchetée**) Spotted, speckled, flecked, blotted, dapped. Cheval moucheté, dappled horse; fleuret moucheté, capped foil.

moucheter, v.t. To spot, to speckle, to fleck; to cap or button (foils).

mouchette (mu'ʃɛt), n.f. Beading, listel, fillet; small plane for cutting these; (pl.) snuffers.

moucheture (mu'ʃtyːr), n.f. Spot, speck; scarification.

moucheur (mu'ʃœr), n.m. (fem. **moucheuse**) Candle-snuffer; nose-blower.

mouchoir (mu'ʃwaːr), n.m. Handkerchief; kerchief; (Shipbuilding) filling-timber. Elle a refusé le mouchoir, she would have nothing to say to him;

jeter le mouchoir à, to throw the handkerchief at, (fig.) to choose out; mouchoir de cou, neckerchief; mouchoir de poche, pocket-handkerchief.

mouchon [MOUCHERON].

mouchure (mu'ʃyːr), n.f. Snuff (of a candle).

moudre (mudr), v.t. (pres.p. **moulant**, p.p. **moulu**) To grind (in mill), to crush; (fig.) to thrash soundly; to produce (music) mechanically. Il viendra moudre à notre moulin, he will want us some day; j'ai le corps tout moulu, I am bruised all over; moudre de coups, to beat soundly; moudre du blé, to grind corn.

moue (mu), n.f. Pout, pouting; wry face, grimace. Faire la moue, to pout; faire la moue à quelqu'un, to make a wry face at someone; vilaine moue, ugly face.

mouée (mwe), n.f. (Hunt.) Sop, hound's fee.

mouette (mwɛt), n.f. Gull, sea-mew.

mouffette (1) [MOFETTE].

mouffette (2) (mu'fɛt), n.f. Skunk.

mouflard (mu'flaːr), n.m. (fem. **mouflarde**) Chubby cheeks.

moufle (1) (mufl), n.m. Muffle (furnace).

moufle (2) (mufl), n.f. Mitten, fingerless glove; muffle; tackle, tackle-block; tie-rod (for walls). **moufle**, a. (fem. **mouflée**) Used only in poulie mouflée, single pulley connected with others in a tackle-block.

mouflon (mu'flɔ̃), n.m. Mouflon.

mouflu (mu'fly), a. (fem. **mouflue**) (prov.) Puffed out, puffy.

mouillade (mu'jad), n.f. Wetting (tobacco etc.).

mouillage (mu'jaːʒ), n.m. Soaking, wetting, watering; anchorage, road-stead. Être au mouillage, to lie or ride at anchor. **mouillé**, a. (fem. **mouillée**) Wet, watery; liquid (of the letter l). Poule mouillée, milksop. **mouille-bouche**, n.f. (pl. **mouille-bouche** or **mouille-bouches**) Luscious kind of pear. **mouille-mines**, n.f. Mine-layer (ship).

mouiller (mu'je), v.t. To wet, to moisten, to steep, to bedew; to dilute; to make (the letter l) liquid. Mouiller l'ancre, to let go the anchor. **mouiller**, v.i. To cast anchor. **mouillère**, n.f. Wet or marshy part of a field etc. **mouillette**, n.f. Sippet (to eat with boiled eggs). **mouilloir**, n.m. Water-can (in which women dip their fingers when they spin). **mouillure**, n.f. Wetting, watering, sprinkling; wet, dampness.

moujik (mu'ʒik), n.m. Muzhik (Russian peasant).

moulage (1) (mu'laːʒ), n.m. Moulding; casting; mould, cast.

moulage (2) (mu'laːʒ), n.m. Grinding, milling; machinery of mill; (Feud. law) mill-dues.

moulant, pres. p. [MOUDRE]

moule (1) (mul), n.m. Mould, matrix; pattern, form; pin. Cela ne se jette pas en moule that cannot be done easily; faire un moule, to take a cast; jeter au moule, moulded, (fig.) Beautifully shaped; jeter au moule, to cast, to mould; moule à beurre, butter-print; moule du bonnet, (slang) head.

moule (2) (mul), n.f. Mussel; (slang) idiot.

moulé (mu'le), a. (fem. **moulée**) Moulded; cast; well-shaped, well-formed. Chandelle moulée, moulded candle; lettre moulée, printed letter. n.m. (colloq.) Print, printed letters. **mouls-beurre**, n.m. (pl. unchanged) Butter-moulding apparatus.

mouler (mu'le), v.t. To cast, to mould; to shape, to form; to show the shape of clearly. Un corsage qui moule le buste, a corsage that shows up the shape of the bust. se **mouler**, v.r. To model oneself. Se mouler sur un autre, to take another for one's model. **mouleur**, n.m. Moulder.

moulin (mu'lɛ̃), n.m. Mill. C'est un moulin à paroles, she is a chatterbox. Faire venir l'eau au moulin, to bring grist to the mill; jeter son bonnet par-dessus les moulins, to throw off all restraint; moulin à café, coffee-mill; moulin à bras, hand-mill; moulin à eau, water-mill; moulin à vapeur, steam-mill; moulin à vent, windmill; moulin de glacier, moulin.

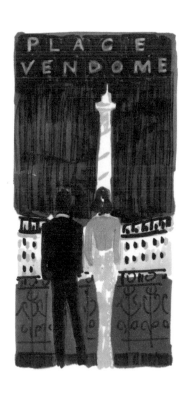

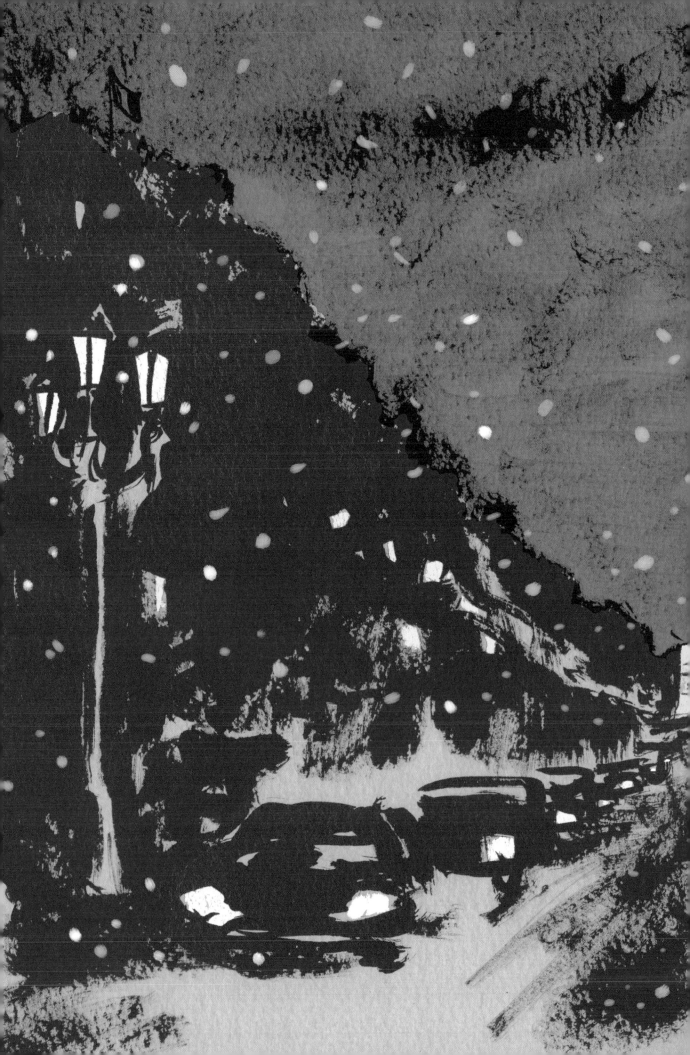

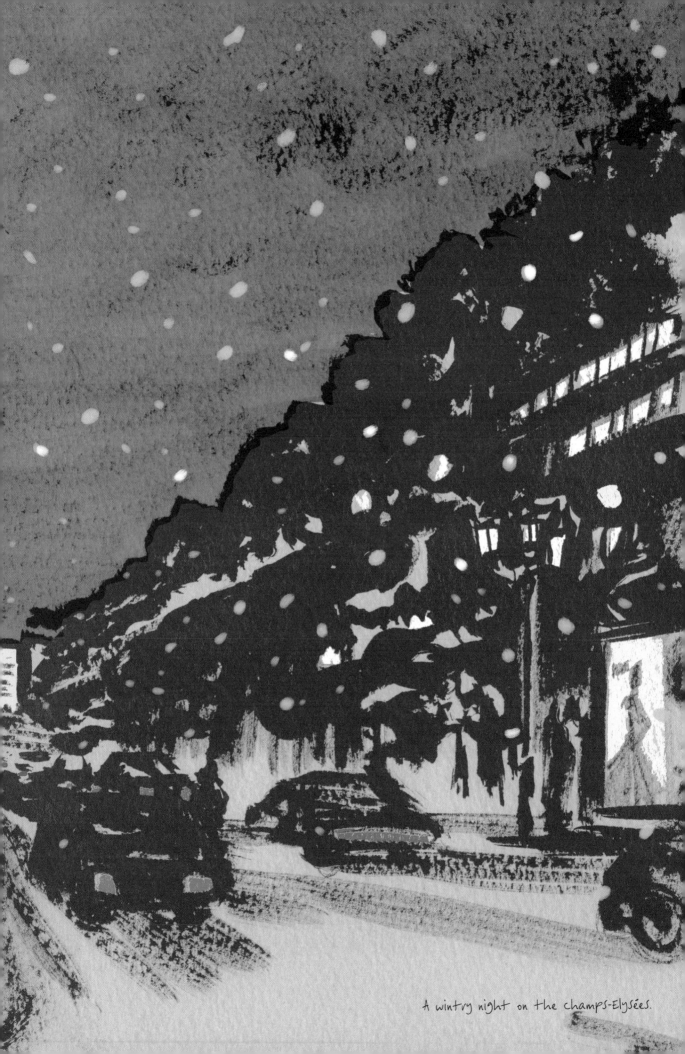

A wintry night on the Champs-Elysées.

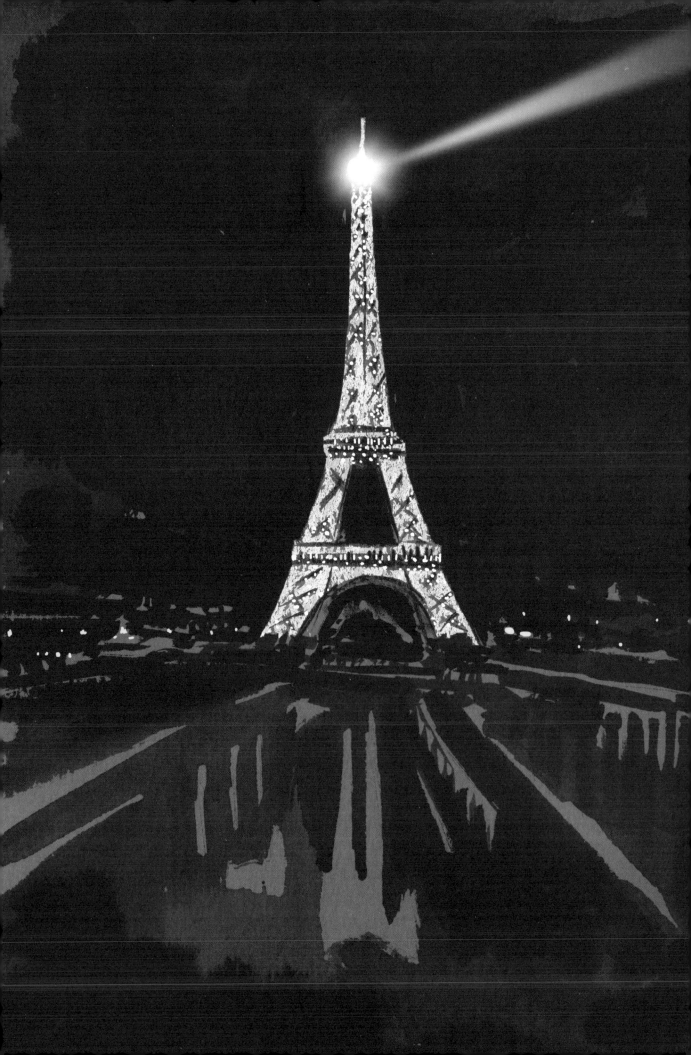

Fin

Dedicated with love to Nila, Lili, Tom
and all my family.

Special thanks to Sarah Batten for
her tireless skill and enthusiasm and to
Helen Rochester for sharing my dream in
commissioning this book. Thanks also to
Angus Hyland, Matt Willey, Tony Glenville
and David Downton. I want to particularly
express my gratitude to the estate
of Henri Matisse and to all the wonderful
shops of Paris who opened their doors
and allowed me to draw.

Published in 2013 by
Laurence King Publishing Ltd
361–363 City Road, London,
EC1V 1LR, United Kingdom
Tel +44 20 7841 6900
Fax + 44 20 7841 6910
enquiries@laurenceking.com
www.laurenceking.com

Copyright © 2013 Jason Brooks

Jason Brooks has asserted his right under the Copyright, Designs,
and Patents Act 1988 to be identified as the author of this work.

This book was produced by Laurence King Publishing Ltd, London

A catalogue record for this book is available from the British
Library

ISBN: 978-1-78067-105-5
Commissioning Editor: Helen Rochester
Editor: Sarah Batten
Printed in China

Bois de

Périphérique

Périphérique France

Gouvion St-Cyr

Boulevard B.

Rue de Saussure

Cardinet

R. de Rome

R. Leger

Hugo

r. Boulevard de Reims

Ave de la Pte Champerret Avenue

Boulevard Pereire

Rue

Rue

Boulevard des B

rique

de

de

Boulevard Pereire

Courcelles

Boulevard

de Wagram

Villiers

Boulevard

Boulevard de Courcelles

Malesherbes

Rue du Ro

Blvd Pereire

Ave des Acacias

Ave Niel

Ave Mac. Mahon

Blvd de Courcelles

Parc Monceau

Hauss

Avenue

Ternes

Ave

Ave Messine

La Boétie

Rue

A. Carnot

Avenue Hoche

Boulevard

Madeleine

Ave

de la Grande Armée

Avenue Friedland

R. Faubourg St-Honoré

Rue Royale

Avenue Foch

Rue de Berri

R. d Ponthieu

A. Ave. Raymond Poincaré

Victor Hugo

Arc de Triomphe

Avenue des

R. Gabriel

Avenue Kléber

Avenue Marceau

Av. George V

Ave Montaigne

Champs-Élysées

Place de la Concorde

D'Iéna

Ave du Président Wilson

Le Grand Palais

Palais de Chaillot

Cours Albert 1er

Pt de l'Alma

Pt de la Concorde

Cours la Reine

Quai de

S E I N E

Jardins du Trocadéro

Quai Branly

Ave Rapp

Ave. du Mal Galliéni

Ave. Alexandre III

Quai d'Orsay

Avenue de New York

Pont de l'Iéna

Ave. Bosquet

Pt des Invalides

Bd. de La Tour Maubourg

Musée d'Orsay

Boulevard

La Tour Eiffel

Ave de la Bourdonnais

AV. Emile Deschanel

R. de Bourgogne

Place des Invalides

rue de Grenelle

Avenue Charles Floquet

Avenue de Suffren

Ave. de la Motte Piquet

Av. Lowendal

Bd. des Invalides

Rue de Babylone

Av. de Ségur

R. Breteuil

R. Eble

R. Oudinot

Q. Citroën

Boulevard de Grenelle

St. Charles

Rue de Sèvres